CONNECTICUT
VANGUARDS

CONNECTICUT
VANGUARDS

HISTORIC TRAILBLAZERS
& THEIR LEGACIES

Eric D. Lehman

THE
History
PRESS

Published by The History Press
Charleston, SC
www.historypress.net

Copyright © 2018 by Eric D. Lehman
All rights reserved

First published 2018

Manufactured in the United States

ISBN 9781625859815

Library of Congress Control Number: 2017960108

CONTENTS

CONTENTS

INTRODUCTION

History is made by the hard work and struggle of millions of human beings, not just a few geniuses and generals. But no one can deny that individuals in the vanguard can do spectacular, even revolutionary things. What does being in the vanguard mean? Innovative, original or full of moxie? The fulfillment or transcendence of your capabilities? The creation of opportunity? Or the improvement of humankind? All these things and more. Mark Twain put it this way: "When we do not know a person—and also when we do—we have to judge his size by the size and nature of his achievements, as compared with the achievements of others in his special line of business—there is no other way." And so, this book focuses on a group of people who were pioneers, groundbreakers or trailblazers in their particular fields.

At first, they might seem like they have little in common. Some were open-minded, some were single-minded. Some were leaders, like Jonathan Trumbull, and some were loners, like Eugene O'Neill. A few like P.T. Barnum you would want to be friends with, and others like Noah Webster could be absolute terrors to friend and foe alike. It's difficult to imagine two people more unlike each other at first glance than Charles Goodyear and Helen Keller. They are a heterogeneous group with seemingly radical differences in philosophy and personality.

However, after a little digging, we begin to find points of contact among them. For a few like Charles Ives and Eli Whitney, being in the vanguard meant creating new paradigms. For others like Ebenezer Bassett, it meant

finding the right thing to do and taking a stand. Almost all were well read, with diverse experiences and diversity of thought, learning everything they could both inside and outside their fields. Most thought outside the box of their discipline like Alexander Calder and Frederick Law Olmsted. Most had fantastic powers of concentration like J.P. Morgan and, like Jonathan Edwards, had clarity of purpose and vision. For many, revolution came from an ability to synthesize different disciplines, to apply medicine to politics like Alice Hamilton or chemistry to crime-solving like Henry C. Lee.

All of them worked hard. Almost all had an ability to deal with failure, sometimes over and over again, taking adversity and turning it into victory. But not always. Sometimes a person like Prudence Crandall just paved the way for others or shifted the playing field. Those who did succeed encountered plenty of good luck but put themselves in position to take advantage of it.

Everyone in this book either grew up among the little hills and winding rivers of Connecticut, like Katharine Hepburn, or spent a significant portion of their working lives here, like Marian Anderson. This place meant something to them, nurtured their talent, pushed them to succeed. And these particular vanguards represent only a fraction of the amazing people doing trailblazing work within the confines of our small state. The inventive spirit and creative work fostered here has permanently transformed the way that humans perceive and interact with the world.

Their accomplishments should inspire us, but we should also pay close attention to the details of their biographies. After all, none of the people described in this book are superhuman geniuses to whom changing the world was child's play. No such people exist. These are all ordinary people who through passion and effort lived extraordinary lives. Revolution starts within.

Chapter 1

JONATHAN EDWARDS

VANGUARD EVANGELIST

The first European settlers arrived in New England to establish the kingdom of God on earth, but their grandchildren did not feel quite as strongly about the project. Sitting through a dozen hours of sermons a week was no longer for everyone, and many were now dissenting from the original dissenting positions of the Congregational churches. By the late 1600s, John Winthrop's "city on the hill" had become a place to seek fortune rather than refuge from persecution. More and more, the people coming to New England were adventurers rather than refugees, merchants rather than religious visionaries. The Puritans had sought stability, and it had brought economic success and global trade.

It wasn't just the business of making money that was changing the culture. Election day, militia training days, corn huskings and tea parties moved these religious folks out of the abstract and into the practical, out of the next world and into this one. Not that they considered themselves a secular society. Far from it—many still talked of creating New Jerusalem well into the 1700s. But whether they knew it or not, their ideal of the future had become an ideal of the past.

By the time Jonathan Edwards was born in Windsor, Connecticut, in 1703, it was clear that they had failed. Or rather, they had created not something old and ideal but something new and strange. Unlike many of his contemporaries, though, Edwards would never lament something lost. No, he grew up believing that in fact he lived in the "city on the hill." With that assumption, he could forge ahead, into new territory of the mind. The

world would soon be supplied by "treasures from America," both practical and spiritual—he was sure of it.

The only boy in a family with eleven children, he watched spiders string their "little shining webs" in the backyard and posited theories on the color of maple leaves. His maternal grandfather, Solomon Stoddard, had been the leading ecclesiastic in western New England, and he grew up idolizing and following this venerable man. His sisters and mother read to him from the Bible and tried to please his kind but demanding father. At age nine, little Jonathan felt he had achieved a "new sense of things," organizing prayer meetings for the children of East Windsor and praying several times a day.

He entered the Collegiate School in Wethersfield at age thirteen, young even for those times, with a new purpose: to become a man of God. By Edwards's third year, a merchant named Elihu Yale gave the money for a building in New Haven to house the college, which was renamed, appropriately, Yale. Edwards settled into the long blue wooden structure on the west side of the town green, studying hard until he contracted pleurisy and nearly died. This experience at age sixteen caused him to alternately declare his religious convictions and to fall "into my old ways of sin."

By the time he began his master's degree at Yale, he was arguing with the ideas of John Locke but also taking them further, suggesting that the mind, too, was an idea, not just a container for them. Still having "great and violent struggles" with his own spirituality, he served as the college butler, trying to quell the cursing, vandalism and petty larceny of his fellow students. He took refuge in the forests and sheep farms north of New Haven, wandering along the banks of the Quinnipiac River, finding a spiritual solace, what he called "a kind of vision…being alone in the mountains, or some solitary wilderness, far from all mankind, swiftly conversing with Christ, and wrapped up and swallowed up in God."

After a short stay in the wild hills of Bolton, he returned to his alma mater as a "tutor," really one of the only teachers at the school. While there, he fell in love with Sarah Pierpont, daughter of one of Yale's founders. She made him outrageously happy, but even his beloved was second fiddle to God. He wrote, "How soon earthly lovers come to an end of their discoveries of each other's beauty; how soon do they see all that is to be seen!"

In 1726, he was invited to join his grandfather Solomon at the church in Northampton, Massachusetts, as a junior pastor. He and Sarah were married in 1727, and soon she was pregnant. Everything seemed to be going right. He seemed to have combined his interests in nature, logic and religion, beginning to write what would become the most impressive collection of

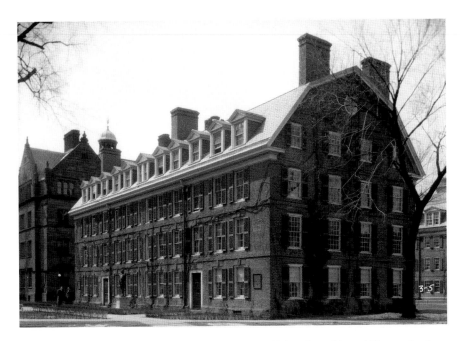

As the state's oldest and most prestigious college, Yale University cultivated Connecticut's vanguard over the centuries. Many of the earliest scholars lived in Connecticut Hall, its oldest remaining dormitory. *Library of Congress.*

sermons in the century. But it was not an easy life. After his grandfather died, Edwards had the responsibility for 1,300 souls, waking at dawn and spending thirteen hours a day working. Anxiety attacks caused him to occasionally lose his voice, and he took long horseback rides and chopped wood for the fire to relieve stress and regain touch with God.

On a Thursday in July 1731, the Harvard-educated worthies of Boston invited this strange young Yale graduate to give the public lecture. He did not disappoint, managing to somehow satisfy the orthodoxy of these strict Calvinists, while subtly shifting the focus away from predestination and toward Christ. His book *A Faithful Narrative of the Surprising Work of God* reached faraway Scotland and England and started revivals there. When it was finally published in America, in 1738, it had already achieved the status of a classic.

By 1735, Edwards had added the language and philosophy of the senses to the cold academic logic of the educated preachers. He wrote on original sin, on the importance of community life, on the nature of virtue and on the question of why God created the world. And he worked on defining true love, which he posited was to make others happy without thought

for ourselves. The Puritans had belittled this sort of "enthusiasm," but Edwards saw it as a necessary part of the Christian ethos. And then, English pastor George Whitefield arrived on October 17, 1740, and sat at Edwards's dining room table, broke bread and talked of new things. Edwards had planted New England with spiritual seeds, and Whitefield found trees ripe for the picking.

During this revival, usually called the "Great Awakening," Whitefield traveled around the country and convinced people by appealing to their emotions. Edwards agreed that this was necessary: "A merely rational opinion, that there is a God from the consideration of the works of creation, is cold, and does not reach the heart." But that did not mean getting rid of rhetorical techniques and intellectual rigor. Unlike many revivalist preachers, Edwards did not distrust philosophers like Pascal or Calvin but embraced academic thinking and the emotional upheaval of the Great Awakening together. He believed that what was true in philosophy could be also true in theology and that emotion and reason could live together in harmony.

Less than a year after Whitefield's revivals had swept New England, Edwards gave a guest sermon on July 8, 1741, in Enfield, Connecticut, called "Sinners in the Hands of an Angry God." It was full of vivid language, exhorting the people to repent "with such gravity and solemnity" and "with such distinctness, clearness and precision" that, as witnesses reported, a "great moaning and crying" took place. He told them:

> *The God that holds you over the pit of hell, much as one holds a spider, or some loathsome insect over the fire, abhors you, and is dreadfully provoked: his wrath towards you burns like fire; he looks upon you as worthy of nothing else, but to be cast into the fire; he is of purer eyes than to bear to have you in his sight; you are ten thousand times more abominable in his eyes, than the most hateful venomous serpent is in ours. You have offended him infinitely more than ever a stubborn rebel did his prince; and yet it is nothing but his hand that holds you from falling into the fire every moment.*

The congregation began to shout, with "shrieks and cries," begging Edwards to save them from this torment. He had matched a unique vision and talent for rhetoric, combining feeling and thinking in a way that few have before or since. Language had become a torch in his hand.

He was a less successful politician. He made mistakes with his constituents in Northampton, pushing them too far with attempts to censor public profanity and sexual proposals. They voted him out of office, and he

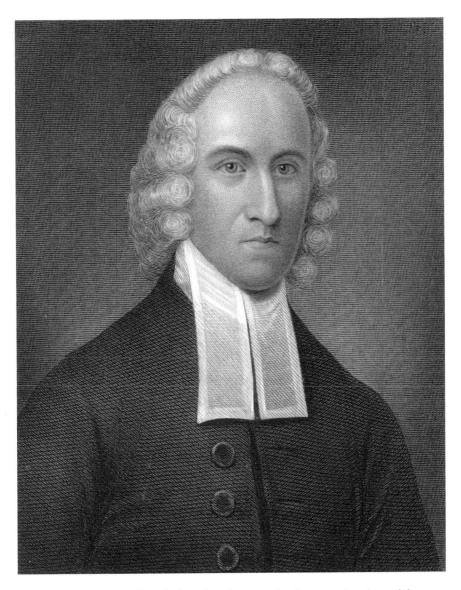

Born in 1703, Jonathan Edwards championed a new style of sermon that changed the way ministers interacted with their congregations. *From* A Library of American Literature, *1888. Magnus Wahlstrom Library, University of Bridgeport.*

preached a farewell sermon in 1750, two months after his eleventh child was born. The man acknowledged as the nation's foremost religious philosopher was out of a job. What could he do? In 1751, he went to Stockbridge, writing and preaching to both Indian and English constituents. Like many writers

and philosophers, he found himself in strained financial circumstances even as his book *Freedom of the Will* influenced Calvinism in both Scotland and America. At fifty-five, he moved to Princeton as a professor of divinity, but just after he arrived, a smallpox inoculation went wrong, and he fell victim to the small red marks of this tiny killer. As he lay dying, he told his daughter Lucy, "It seems to me to be the will of God that I must shortly leave you; therefore, give my kindest love to my dear wife, and tell her, that the uncommon union, which has so long subsisted between us, has been of such a nature, as I trust is spiritual, and therefore will continue forever."

In some ways, Edwards had failed in his purpose. No new reform swept the land, and the culture kept changing at an uncomfortably fast rate. Future generations of ministers lambasted him as a "fire-breather," despite his philosophical complexity and literary skill. But without even being aware they were doing it, these same ministers modeled themselves on Edwards, combining the emotion of the revivalists with the intellectual rigors of the academics. He had injected an urgency back into American Christianity that it desperately needed.

Meanwhile, his sermons and essays continued to be printed and read by hundreds of thousands of people across the globe. They pondered his valiant attempt to reconcile the freedom of the will and the omnipotence of God, while enjoying his unique blend of scripture and reason. He became the first American minister with a fully international reputation and the only one whose sermons continued to be read as the centuries passed. He had transfigured the role and impact one local preacher could have.

Chapter 2

JONATHAN TRUMBULL

REVOLUTIONARY LEADER

When Jonathan Trumbull was born on October 10, 1710, his small village of Lebanon was a bare clearing along a Native American path. The creaking wooden house groaned under the weight of winter snows, and the family could be stuck inside for weeks with no contact from friends or neighbors. The streams and rivers cutting around the upland hills created swamps, while thickets and mountain laurel choked the dark brown loam of the soil. Growing up, young Jonathan helped his father clear the fields, girdle trees and root out stumps. He participated in the endless job of removing "New England potatoes," or small glacial rocks, and piling them onto walls. He picked raspberries and grapes, fished for shad and trout and hunted rabbits and deer. Industry and diligence were the cardinal virtues, and reluctance was more than frowned upon. Trumbull learned this lesson well, and whatever his faults, shirking from labor was never one of them.

Because his older brother would take over the farm, Jonathan could pursue his own endeavors. He began his training as a Congregationalist minister at Harvard, while also learning Hebrew, math and astronomy. He joined the "Private Meeting," a fairly new religious society at the university, whose mission was to "edify, encourage, and excite one another in the ways of Holiness, and Religion." They met twice a week, kept the content of the meetings secret and generally tried to lead a spiritual life at the somewhat secular Harvard of the 1720s. He graduated in 1727, returned three years later to get his master's and was invited to be the minister of Colchester, Connecticut. He was on the path to join Jonathan Edwards as one of New

England's "lights." But it was not to be. His brother was lost at sea, and his father called on Jonathan to take over the family business as a combination farmer and trader, carrying on an import-export business with the Caribbean and England.

At five feet, six inches, with a hawk-like nose and large, drooping eyes, he did not grow into the most attractive man. But he found love and in 1735 married Faith Robinson, daughter of a preacher. Lying at the confluence of paths between Hartford, New London and Providence, Lebanon was growing, and though Trumbull was not the minister, as the owner of the largest farm and country store, he became the next most important person in town. Indeed, not being able to serve the community as a man of the cloth must have led him to serve it in a civic capacity. In 1736, he became Lebanon's state representative, and when only thirty years old, he became the Speaker of the House. Over the next twenty years, he served in the Senate and on the Council of the Governor, as well as the justice of the peace for Windham County, judge of probate courts and judge of the Connecticut Superior Court.

Connecticut's population exploded during the middle years of the 1700s, both through births and immigration, and the Great Awakening further destabilized the state. Trumbull was called upon by the assembly to mediate in many quarrels and religious questions, including the boundary dispute with Massachusetts, an old question that had been gnawing at the two states' relations for a century. He also took part in strategy sessions with other colonies before, during and after the French and Indian War. He negotiated with England during a controversial case between Spain and the colony, a matter that threatened Connecticut's sovereignty and its reputation abroad. By the end of the French and Indian War in 1763, he was already the state's most respected public figure.

How could Trumbull maintain his business affairs and yet remain a solid foundation of the colony's government? The short answer is that he couldn't; no one could, and so his business suffered, leading to one of the contradictions of his life. He could not give up his business, both because it brought him the money needed to live and because it brought him the status he needed to serve in the state government. But his service to the state hurt his business and put him into debt. Trumbull must have believed very strongly in public service, and in the government's potential power to do good, to have given up so much. But his inability to pay his debts also arose from the incapability to call in the £10,000 owed him by customers. The middleman's job was much riskier in those days, without

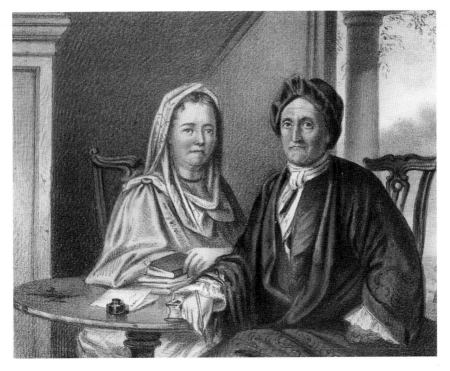

Jonathan and Faith Trumbull led the state, and the nation, through its difficult birth. *From* Life of Jonathan Trumbull, Sr. *by Isaac Stuart, 1859. Magnus Wahlstrom Library, University of Bridgeport.*

protection from the government, and throughout the 1760s and beyond, he continued to thwart creditors.

The state contributed more than its share of supplies and soldiers for the French and Indian War, particularly during the assaults on Canada that led to the capture of Quebec. During this process, Trumbull learned how to provision an army, a skill he would use to great effect during the Revolution. And yet, just after the war in 1765, the Sugar and Stamp Acts put the burden of the war on the colonists. The governor, Thomas Fitch, would not denounce the British Parliament or refuse the acts and tried to force his Council of Assistants to take the oath to enforce them. Trumbull and three other members from eastern Connecticut protested by walking out. The following year, he and his former business partner William Pitkin ran against Fitch for governor and deputy governor and won. Trumbull wrote that "it is always to the interest of the Mother country to Keep them [colonies] dependent....But if violence or methods tending to violence be

taken to maintain their dependence, it tends to hasten a separation." He wasn't ready for violence yet and adopted the strategy of boycotting British goods, but it was only a matter of time.

Upon hearing of the shots fired at Lexington and Concord, Trumbull immediately opened the Lebanon family store and gave free supplies to the militia headed for Massachusetts. The only governor not summarily booted from office at the outbreak of war, he convened his "Council of Safety" at the small store, where it would meet over nine hundred times during the war. His network of connections brought information in, while supplies went out: corn and oats, shad and pork, lumber and pitch. He passed legislation to curb inflation, issued a responsible amount of paper money and used a "pay as you go" policy for war expenditures. He also embargoed a number of items, unfortunately leading to the smuggling operations from Fairfield County to Long Island and back throughout the war. Nevertheless, the nationwide operation he assembled was by far the most productive per capita of any colony, producing not only food but also gunpowder and shot more rapidly than anywhere else.

The aged General Israel Putnam, Washington's second-in-command during the early years of the war, said of "Brother Jonathan" that he "dared to lead where any dared to follow." He and Washington corresponded more than any other two people during the war, and their mutual esteem grew greater every year. His wartime leadership included daily and weekly ration schedules of things like butter and coffee, as well as clothing quotas that required each town to supply the troops.

Knowing that Connecticut could not remain separate from its fellow colonies, Trumbull pushed its people from a politically autonomous, regionally concerned group to nationally concerned citizens. The Connecticut *Courant* wrote on April 22, 1776, "An American state or empire is much talked of; the materials of which it is to be formed are a number of flourishing colonies and possessions, heretofore independent of each other; the materials are noble and the building vast." Only two months later, the state's assembly under Trumbull sent its delegation to Congress to support independence and plan a union for "the security and preservation of their just rights and liberties, and for mutual defence and security."

They say an army travels on its stomach, and Washington's army was often starving. During the terrible winter at Valley Forge, he wrote to Trumbull about the "alarming situation of the army on account of provision," saying that he had given up on receiving more food from the southern and middle states and "there is the strongest reason to believe that its [the army's]

existence cannot be of long duration, unless more constant, regular, and larger supplies of the meat kind are furnished....I must therefore, sir, entreat you in the most earnest terms, and by that zeal which has so eminently distinguished your character in the present arduous struggle, to give very countenance...to forward supplies of cattle." Trumbull immediately collected a herd of three hundred, and Colonel Henry Champion drove them to Pennsylvania. The troops devoured all the meat in under five days. But by then Trumbull was sending more cattle, along with barrels of salted shad and pork.

Two years later at Morristown, Washington's soldiers were again starving, while the worst blizzard of the century hit New Jersey. He again turned to his Connecticut friend, saying, "The army has been near three months on a short allowance of bread; within a fortnight past almost perishing. They have been sometimes without bread, sometimes without meat; at no time with much of either, and often without both....We are reduced to this alternative, either to let the army disband...or...to have recourse to a military impress....Our situation is more than serious it is alarming." Trumbull sent the messenger back with a list of provisions, along with specific days and hours Washington could expect the food. And he kept his promise, along

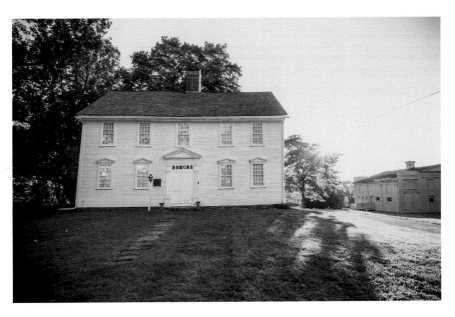

From his house in Lebanon, Governor Jonathan Trumbull directed the war effort, including shipments of provisions to the Continental army. *Photo by David K. Leff.*

with dozens of others that he fulfilled to the Continental army, militia and ordinary citizens throughout the war.

By the end of the war, Trumbull had lost his wife to dropsy, daughter to suicide and eldest son to a paralytic illness, though he had earned the title "first of the Patriots" from his friend George Washington. His popularity in the state was not as secure. Like many wartime leaders, Trumbull was forced to make unpopular decisions, and wartime taxation was certainly a problem for him after the war was over. The small farmers of the state rebelled when a tax was levied to pay the soldiers of the war, pitting two constituencies against each other, and at that time farmers were a majority. Trumbull's position on the other side of the question was the doom of his political career. Though future generations would see the payment of men who had served in war a national responsibility, as Trumbull did, the national feeling was not high enough at this time.

Before he retired, Trumbull did one more thing: support the creation of a strong central government to unite the former colonies. "They are our brethren," he said of the fellow American colonists. "They are men, who from interest, affection, and every social tie, have the same attachment to our constitution and government as ourselves." His pleas would not fall on deaf ears, and others in the Connecticut vanguard like Oliver Ellsworth and Noah Webster would continue that work.

After leaving office, Trumbull began to study Hebrew again, wrote sermons and took daily walks to the Lebanon cemetery to see the graves of his son, daughter and wife. He died deeply in debt, but the new country's debt to him was far greater. He had wanted to be a minister and never sought glory or control. But this reluctant leader served anyway. This may at first seem a contradiction, but in a democracy, a leader should always be a servant of the people, working for the good of the community and a better world. Trumbull showed Connecticut, and America, just how that could be done.

Chapter 3

OLIVER ELLSWORTH

TRAILBLAZING LAWYER

Born in Windsor four decades after preacher Jonathan Edwards, on April 29, 1745, Oliver Ellsworth found himself less suited for the ministry. Nevertheless, he studied for five years under one of Edwards's most promising disciples, the Reverend Joseph Bellamy, who taught him that we should not "forsake" this world but instead attempt to improve it through patient and rational governance. His Connecticut farmboy upbringing also granted him a pragmatic ability to compromise, and in both church and school, he learned the important relationship between the individual and the community.

By age seventeen, he was over six feet tall, with a strong jaw and muscular frame. He headed to Yale but was kicked out for "pranks," including wine-drinking and protesting, and instead attended the upstart College of New Jersey. Like many students in the 1760s, he began to entertain radical ideas of self-government and, along with classmates Aaron Burr and William Paterson, founded a pro-republic political society. He was once again nearly kicked out of school, this time for wearing a hat in the college yard, but he argued his way out of it. He was learning the art of rhetoric well.

Graduating Phi Beta Kappa in 1766, he went back to enter the ministry in Connecticut, but when his mentor asked him to prepare a sermon, he wrote a legal argument instead. It was clear that law was a more suitable vocation, and after four years of study, he was admitted to practice. To pay for his schooling, he took an axe to a woodland lot and sold the timber. A year later, he married the enchanting, black-eyed Abigail Wolcott, daughter of another

of the state's most important families. She cared with "such concern and thoughtfulness" for Ellsworth that he was able to focus all of his axe-wielding energy on public life. On one occasion, she milked the family cow while at the same time rocking her baby with a string attached to the cradle.

Ellsworth was elected to state office in 1773, and his law practice thrived despite or perhaps because of the growing conflicts with England. He walked to work five miles every day, summer and winter, and at one point had 1,500 cases on his docket. His eloquence was commented on by his contemporaries, the Hartford Wits: John Trumbull talked of the "thunders of his eloquence," and Timothy Dwight remarked on his "vehement and overwhelming" style.

During the Revolution, he became state's attorney and helped Jonathan Trumbull govern the state, working with him on his most important councils. He also served as a delegate to the Continental Congress in Philadelphia, working hard on the Committee of Appeals, a precursor to the Supreme Court. Like many men of his generation, he believed that public service was the highest calling, and his incredible work ethic and knowledge of law soon made him a leader in both the state and federal domains.

In 1782, Ellsworth realized that the Revolution was successful and commissioned the building of a house in his hometown of Windsor. He planted thirteen elm trees in honor of the original colonies that rebelled, calling the home Elmwood. Its Georgian clapboards and Tuscan columns would shelter him for the rest of his life, along with his growing family of nine children and visitors like John Adams and George Washington.

As the feeble government struggled toward a constitution, Ellsworth continued the role he had begun on the Committee of Appeals, acting as judge on the Supreme Court of Errors and then the Connecticut Superior Court. In 1787, the state's General Assembly sent the forty-two-year-old judge to the convention in Philadelphia, where he and a group of other men drafted the Constitution. On June 20, he proposed that the name "the United States Government" be used to identify the administration. It was a term already in informal use, but other proposals had been put forward, including the "National Government." His successful argument guaranteed it remained in use, and it has to this day.

Perhaps more importantly, he, Roger Sherman and William Samuel Johnson created what was called the Connecticut Compromise. Sherman was no rhetorician, though, and Ellsworth took the lead, persuading fellow delegates to accept the bicameral legislature, splitting the legislative branch into the House of Representatives and the Senate. Contradicting both

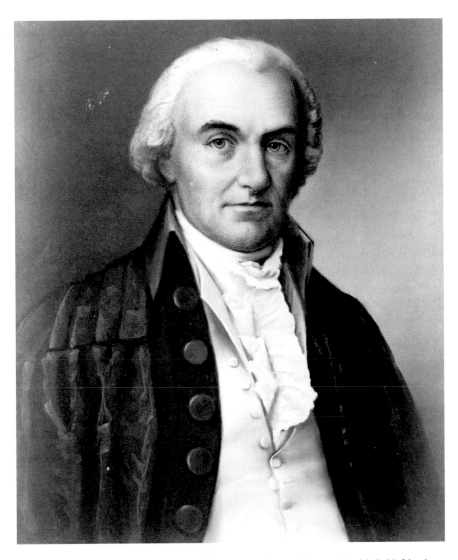

Oliver Ellsworth helped write the laws of the new nation and became its third chief justice. *Library of Congress.*

large and small state arguments, Ellsworth said that the United States was "partly national, partly federal" and therefore needed this double system. "Let not too much be attempted by which all may be lost," he said, urging his fellow delegates to compromise. On the morning after Independence Day 1787, they did, and two weeks later, the legislative structure of government was ratified.

Ellsworth saw his job at the convention to reproduce the pleasant unity of his home state on the national scale. Not all his proposals were successful, such as his arguments for the abolition of slavery. In fact, only James Madison and Gouverneur Morris spoke more than he did during the sixteen days from August 6 to August 23. He had to leave the convention after this but the following year helped ensure that Connecticut ratified the new Constitution. "A power in the general government to enforce the decrees of the Union is absolutely necessary," he said in an emotional opening address.

Like many of the revolutionaries, he had already done enough, helping to craft a new nation. But he did not stop working, and when Connecticut elected him senator, he gladly accepted, taking his seat in 1789. Acting as a Senate majority leader would today, he supported George Washington as the first president's "firmest pillar," according to John Adams. Ellsworth introduced "Senate Bill No. 1," the Judiciary Act, with his old classmate William Paterson, even though they had disagreed on the Connecticut Compromise two years earlier. This created a hierarchy of state and federal courts, granting the U.S. Supreme Court the power to veto any lower court decisions.

While the Judiciary Act gave the federal government more power, Ellsworth also sponsored the Bill of Rights in the Senate, preventing abuse of individuals and states by the same federal government. It was the kind of bold move only someone committed to balance and long-term planning could have made. He also helped pass Alexander Hamilton's economic reforms, even though he often disagreed with the New Yorker. He convinced Washington to send Chief Justice John Jay to negotiate with England in 1794 and worked on getting Rhode Island and North Carolina admitted into the Union. He was so influential that his old classmate Aaron Burr lamented the fact, saying that nothing happened in the Senate without his say-so. Timothy Dwight said, "His presence was tall, dignified and commanding....There was probably no man, when Washington was not present, who would be more readily acknowledged to hold the first character."

In 1796, Ellsworth's contributions to the laws of the new nation were honored in the highest way possible when George Washington appointed him Jay's successor as chief justice of the Supreme Court. He and his fellow justices affirmed that the president had no part in the process of amending the Constitution and decided that "ex post facto" did not apply to civil cases. More importantly, perhaps, he began the ongoing tradition of consensus, in which the rulings of the court are given one written opinion, no matter which way individual justices might have voted. Meanwhile, in

1796, he won eleven electoral votes in the presidential election, though he had not sought the role.

Just as Chief Justice John Jay had negotiated the treaty with England in 1794, Ellsworth was appointed by President Adams to negotiate with France. Tensions were high, and the American public had been agitated into wanting war with this former ally. While in France, Ellsworth's house was attacked by robbers, but the gardener drove them off with a gun. Ellsworth assured his sons in a letter that "daddy" was safe, though, because he "keeps a gun and two pistols charged at all times." But he kept a clear head in negotiations, impressing Napoleon so much that the temperamental French leader agreed to peace terms. Indeed, Napoleon's good opinion of Ellsworth might have contributed to his willingness three years later to sell the Louisiana Territories.

He came down with "the gravel and the gout" during these travels and remained in great pain most of the time. Due to this, he resigned as chief justice, living a quieter life at Elmwood in his hometown of Windsor, serving on the Connecticut legislature and keeping up his law practice for the next

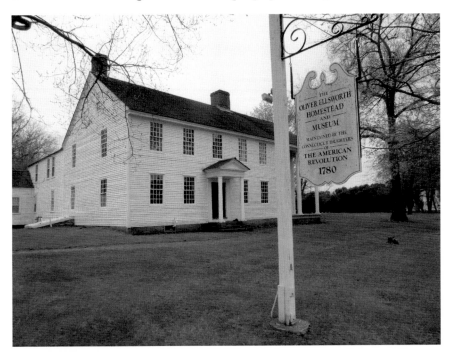

Settled along the banks of the Connecticut River, this house gave trailblazing lawyer and judge Oliver Ellsworth sanctuary from his legislative duties. *Photo by Trena Lehman.*

seven years. He was content there, saying, "I have visited several countries, and I like my own the best. I have been in all the States of the Union, and Connecticut is the best State; Windsor is the pleasantest town in the State of Connecticut and I have the pleasantest place in Windsor. I am content, perfectly content, to die on the banks of the Connecticut." He was buried overlooking the Farmington River in the place he loved the best.

Ellsworth found, as so many others have, that the law was not only something to prosecute criminals or keep people from one another's throats. It was a force that shaped and bound people into communities, providing a cultural framework that could bend and adapt but not break. It could even create a nation where once there had been none. But he also knew its limits. In his "Landholder" essays for the Connecticut *Courant*, he wrote, "Perfection is not the lot of human institutions." In another, he warned, "When we become ignorant, vicious, idle, our liberties will be lost—we shall be fitted for slavery, and it will be an easy business to reduce us to obey one or more tyrants." Ellsworth believed that law is merely a skeleton on which the body of a country is built.

Ellsworth has been practically forgotten, even in his own state. His hard, thankless work remains unthanked. But no doubt he would not care for honors or applause. For him, the work was its own reward, and the fact that the system of law he helped create has lasted over two hundred years would be reward enough.

Chapter 4

ELI WHITNEY

INTREPID INDUSTRIALIST

In 1797, Eli Whitney returned to New Haven in despair. During a tutoring job in South Carolina, he had invented a small machine that separated cotton from seeds, had promptly marketed this "gin" and just as promptly had it stolen. The rights of property and patents were not yet codified into law in the new nation, and his lawsuits fell on deaf ears. "The difficulties with which I have had to contend," he said, "have originated principally in the want of a disposition in Mankind to do justice." He spent years fighting this inequity but finally gave up in disgust. "It has required my utmost exertions to exist," he wrote in near despair. "I have labored with a shattered oar and struggled in vain."

What could he do, now that teaching was years behind him and his first project a financial failure? It would have to be something with his hands. As a child in Westborough, Massachusetts, he had shown extraordinary promise, crafting chairs, reconstructing a pocket watch and even building a violin from scratch. During the Revolution, he had forged nails and hired an assistant, even though he was only a teenager. When he was twelve, his sister claimed that he had "more general knowledge than men considered of the first standing in the country." As the English flooded the market with nails, he switched to hatpins and then walking canes.

Now in the 1790s, the newly united states were still suffering a postwar recession, and Connecticut's small size gave it a further disadvantage. In 1798, war with France threatened, and Whitney saw his chance, writing a letter to fellow Yale grad Oliver Wolcott, now the secretary of the treasury.

Wolcott pushed through a contract with Whitney to manufacture between ten and fifteen thousand muskets. This outrageous number was doubly outrageous considering he did not even have a factory or the capital to invest. But the government gave him black walnut stocks and $5,000, enough to start the project. He had an idea where to build; from New Haven, you could see the notch under East Rock just north of town, where a small mill had turned for over 150 years. He proceeded to replace the old corn mill and hammer up a building seventy-two feet long, thirty feet wide and two stories high. "Worn out with fatigue and anxiety," he hired every available man in the county to help. A boardinghouse was erected for unmarried employees, and Whitney had created one of the first factory towns in America.

Whitney's plan was to use interchangeable parts, allowing any part of any gun to match another. A few factory owners had attempted this in a basic way, but fewer with such complex technology, and none on such a scale. The lock of a musket required precise calculations, and the consequence of getting it wrong could be the death of the operator. The Industrial Revolution was only three decades old, and taking what had always been the art of skilled craftsmen and turning it into a regulated, methodical process, using not only interchangeable parts but also division of labor, was considered to be risky or even insane.

It was certainly not easy. He wrote, "I find that my personal attention is more constantly and essentially necessary to every branch of the work than I apprehended." Working sixteen hours a day, seven days a week, he dealt with things like import tariffs and river flooding without any guidance or previous lessons. As far as his employees, he decided to divide them into specialized jobs, a bold experiment. Economist Adam Smith's ideas about division of labor had not been put into practice with such precision, and even in the new clothing factories in Massachusetts and New Jersey, the method was not utilized properly or needed as much. Whitney broke down the process and trained different workers for each step, specialization that would become a hallmark of factory work in the coming centuries.

Whitney not only improved upon and combined industrial techniques, but he also realized that in order to facilitate mass production, he would have to launch a new industry: tools to make tools with. "In short," he said, "the tools which I contemplate are similar to an engraving on a copper plate from which may be taken a great number of impressions exactly alike." By 1801, he had developed a drilling machine, a boring machine, a screw machine and a triphammer, all of which are still used in factories today. These kind of precision machines were rare, to say the least, and he did not pursue patents

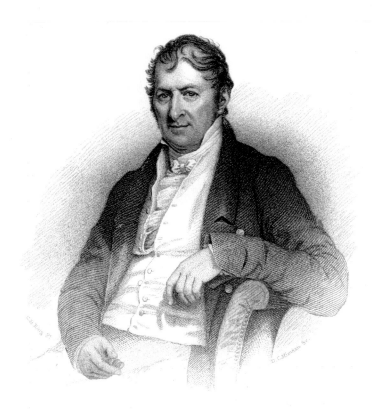

After the design for his cotton gin was stolen, Eli Whitney turned to gun manufacturing, creating the first modern factory and industrial village. *Hamden Historical Society.*

because few could even figure them out. After the trouble he had with the cotton gin, he never patented anything again for the rest of his life and philanthropically gave away his designs in ways that would be considered business suicide today.

All these methods, especially the use of interchangeable parts in devices as complex as guns, were considered impossible by most people. He could ignore public opinion, but the government was another matter. At one point, he had to convince America's growing bureaucracy that his slightly higher prices were worth the money, and he used cost-benefit analysis that included insurance and machinery budgets. This type of accounting was rare at the time, and Whitney helped popularize it. His demonstration of interchangeable parts was even more successful. Traveling down to Washington, he met with the incoming president, Thomas Jefferson, in

order to sell him on the project. With Jefferson and the entire cabinet watching, Whitney tossed a collection of gun parts on the table. With his eyes closed, he grabbed random pieces and assembled a gun, prompting the others to do the same. Jefferson was sold and invested more money in the Hamden factory.

New orders for guns meant more work. At the age of forty, Whitney still had no wife, calling himself "a solitary being, without a companion and almost without a friend." But he had created what the government considered "the most perfect" factory in the country, with superior products and yields. The road that would eventually take his name was widened and the Hartford Turnpike constructed "between the house and the mill," creating "one of the most beautiful and most considerable roads in New England; being nearly in a straight line from New Haven to Hartford."

He produced fifteen thousand guns during the War of 1812, and his methods and machines were modeled by Springfield and Harpers Ferry armories. Militia were posted around the Hamden factory to protect it from possible British invasion or sabotage. He continued to experiment, using well-seasoned pine boxes to ship weapons, over a century before this became common practice. He built a water-driven cutting machine and the first true milling machine in the country, in what was called a "revolutionary technological advance." He gave away the plans to his barrel-turning machine and triphammer. In fact, he gave away everything, transforming American industry through his generosity, content to make enough money to live comfortably and to see his company thrive.

After decades of single-minded labor, he had created an entire village, with three houses, a beautiful barn, five apartment buildings, an office, seven forges and a long series of storehouses; a lumberyard, a canal and gigantic piles of copper tubes, blistered steel, leather, asphalt, glass and iron; a grindstone lathe, milling tools and whipsaw, drilling, screw, stamping and polishing machines—all the technology used in industry for the next two centuries. Whitney had created the first advanced factory in the United States.

All this effort had its costs; he gained stomach ulcers but made few friends and enjoyed little leisure time. "I have a great task before me and when I shall get through, God knows. I live constantly out at my place and tho' I have at least forty people around me every day—I am yet a solitary Old Bachelor," he said wearily. Finally, in 1817, at age fifty-two, he met Henrietta, the granddaughter of Jonathan Edwards, and though she was two decades younger, he courted her and they were married. Late in life,

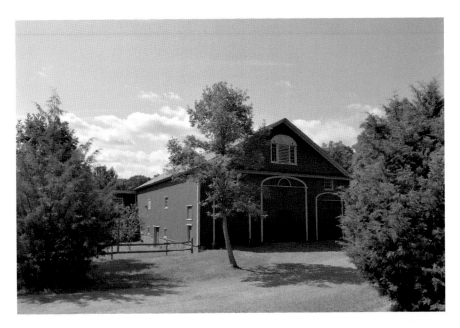

Built in 1816 and remaining in Hamden today, Eli Whitney's barn was praised by residents and presidents alike. *Courtesy of the author.*

he finally had children and had a few years of personal and professional happiness. He invented yet another kind of triphammer. He gave architect Ithiel Town good advice on the lattice truss "covered bridge," the first of which was built across the Mill River just by his factory. Professor Benjamin Silliman at Yale noted that Whitney's inventions were present in "every considerable workshop in the United States." At last, in the 1820s, he began succumbing to an unknown illness, noting, "I am not now able to sit up more than three hours in a day." But he could look with pride on his accomplishments, and his nephew and son would take over his business and guide it through the Civil War, in the place already called Whitneyville.

Because of Whitney, Connecticut became a center for American arms manufacturing for the next 150 years, with names like Oliver Winchester, Samuel Colt and Elisha Root following in his wake. Even more importantly, factories of all sorts would make their homes here. Whitney had solved the "small state" problem that Oliver Ellsworth had worried about: if Connecticut could not compete with Ohio or Virginia in farming, it certainly could compete in manufacturing. Soon our "Yankee ingenuity" became legendary worldwide.

Machine tools, interchangeable parts, division of labor, factory housing, modern accounting methods—Eli Whitney was not the first to try any one of these things. Others would soon take factories and make them bigger, faster, better. But this master of synthesis was the first to put all the elements together and demonstrate what it took to solve problems, create innovative products and succeed in business. He rose above injustice and persevered, transforming the modern world in ways his contemporaries could not even imagine.

Chapter 5

NOAH WEBSTER

RELENTLESS LEXICOGRAPHER

Born in 1758 in West Hartford, Noah Webster was an introverted child. He read books instead of picking apples on his father's farm but hated school. His classmates probably disliked him, too, since even his friends described the red-haired, gray-eyed boy as vain and stubborn. He was anxious and alienated, an opinionated loner. However, instead of just lamenting his situation, he decided to do something about it and went on to dedicate his life to improving American education.

At age fifteen, he enrolled at Yale, just as the first Continental Congress was meeting in Philadelphia. He often fondly recalled playing "Yankee Doodle Dandy" on his flute as George Washington rode through New Haven on his way to the siege of Boston. Later, he marched with his family to rally against the invasion of British general Burgoyne, though he did not get to fight alongside fellow New Havenite Benedict Arnold at the American victory. As a student, he focused on philosophy, and after graduation, he found a job in Hartford as Oliver Ellsworth's law clerk. He soon moved to Litchfield to take classes with Tapping Reeve at America's first law school, working part time as a tutor and trying to seduce local farm girls.

But as British troops began leaving America in 1782, he started one of the two projects that would define his life. One of the things he had hated about school was the English spelling book, full of foreign names and topics. What we needed now, he decided, was the *American Spelling Book*, as he called it, with American references, regularized pronunciations and clear rules and

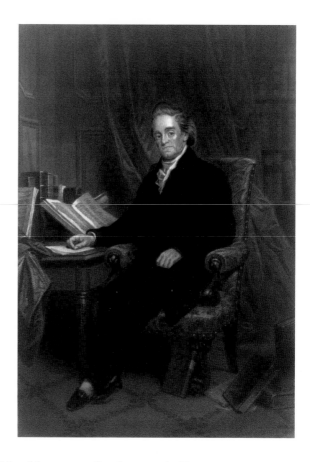

Noah Webster worked for decades to complete his groundbreaking works of lexicography. *Library of Congress.*

regulation. Published with a blue cover, for the next half century it became known to everyone in the country as the "Blue-backed Speller."

It went through eighty-eight editions between 1783 and 1804 alone and, against all the rules of publishing, continued to gain in sales, topping over one million a year in the 1840s, easily the best-selling book in early America. It was praised by Jefferson Davis just before the Civil War as the book that "united us in the bond of a common language," and this "Yankee" book continued to be published throughout the war. Remarkably, the "Speller" was only Webster's second-greatest creation.

As Webster traveled around the newly united states on one of its first "book tours," it became clear that he was great at talking to people one on one. He visited Mount Vernon to meet George Washington and helped convince him that the Articles of Confederation were not powerful enough to keep the country together. "We cannot and ought not wholly to divest ourselves of provincial views and attachments," he wrote in the book he

gave Washington, *Sketches of American Policy*. "But we should subordinate them to the general interests of the continent." After a game of whist and a night's rest, Webster left but returned again to convince the great general that American educators and education were necessary for the country to be truly independent.

However, Webster's skills did not shift easily to more public discourse, and his flamboyant and arrogant style when writing for the newspapers often earned him as many enemies as it did friends. Still, Webster was one of a few dozen writers who helped leaders like James Madison and Alexander Hamilton sell their vision of America to the people. In the summer of 1787, he made sure to be in Philadelphia, where he witnessed Connecticut inventor John Fitch sail the world's first steamboat on the Schuylkill River. And more importantly, he was there for the signing of the Constitution on September 17. Even though he had barely participated in the war and was not a delegate, he could be happy that he had some small part in the proceedings. However, his egotism was unsatisfied with a small role, and he searched for something he could do to "unite" the country further. Without this grandiose arrogance, he probably would never have started his next project, which was so ambitious as to be laughable.

His more philosophical desires would have to wait a little while, because he had met a rich Boston lady named Rebecca Greenleaf and was putting his energies into wooing her and getting a steady job. Telling her that she was "my only happiness, and your happiness the great object of my pursuit," he tried to find some regular employment. Instead, he spent the next couple years borrowing money from her family, writing abolitionist treatises against slavery and living at the houses of friends like Oliver Ellsworth and Jeremiah Wadsworth. His law practice never really got off the ground, and his lecture tours and book royalties were only sporadic sources of money.

Finally, in 1796, he settled into 155 Water Street in New Haven, the former home of Benedict Arnold. Perhaps he thought that his project to unify America would exorcise any ghosts of treason. Or perhaps he just got a good price for the large two-story house with its orchard of peach and cherry trees. Just two years later, he read a neighbor's book that changed his life. Samuel Johnson of Guilford, Connecticut, published a short dictionary for schools, essentially an abridgment of an English version. But its second edition included a few "American" words, like "president" and "tomahawk." It was a small start, but no more than that, Webster thought, toward a national language. He could do better.

On June 4, 1800, Webster announced his intention to the *Connecticut Journal*, telling readers of a plan to complete "a Dictionary of the American Language, a work long since projected, but which other occupations have delayed till this time." News of the idea went national, with contempt and mockery heaped on him from both political parties and nearly every newspaper. He ignored this criticism, used to the venomous world of journalism and politics, and began to write. This public declaration looked foolish but may have been necessary to commit himself to what was sure to be a life work.

As he walked around town, people would ask him, "Finished yet?" Some were joking, and some were serious. All underestimated the work. It was a vast project, much too large for one man, unless that man was as stubborn and as arrogant as Noah Webster. He instructed his own children, who grew more numerous every year; continued to fight people in the newspapers; and worked on other projects like his children's encyclopedia, *Elements of Useful Knowledge*. But all the while, he ground away at his dictionary. He would wake up before dawn and work until four o'clock in the afternoon at a large circular table, occasionally standing up to pace back and forth. Six years after he began, he published a short version of forty thousand words, but this was merely one spire of his incredible palace of language.

Money problems forced him to sell the Arnold house and move to Amherst, Massachusetts, for a while, milking cows like a gentleman farmer. But he found the tiny farm there too remote, and when a blockbuster sale of the spelling book increased his fortunes, he moved back to New Haven into a custom-designed house on Temple Street. He was a rich man now and could retire in leisure. But money had never been his object. The dictionary had become an itch he needed to scratch, even as he converted to Calvinism and dropped out of public sight for years at a time. Only occasionally someone would remember his project and write a satire of him in one of the newspapers. He replied less often to these screeds, perhaps mellowing with age. Instead, he burned the energies of his over-fertile brain on *Synopsis of Words in Twenty Languages*, an 1817 work of such circular logic and flawed methodology that biographer Joshua Kendall called it his "private dream world."

Finally, on November 26, 1828, at age seventy, Noah Webster finished his dictionary. His work contained seventy thousand words, twelve thousand more than its British counterpart, and was an *encyclopedic* dictionary, with a distinctly American soul. It changed spellings from English to American

The *American Spelling Book* and *American Dictionary of the English Language* helped define the country's vernacular, with spelling, subjects and pronunciation that distinguished our language from British English. *Library of Congress.*

versions, such as centre to center and colour to color. Webster was also the first lexicographer to use his own examples as part of the definitions themselves, crafting each into a small essay focused on the word itself. Consider the newly comprehensive definition for "Genius."

> *GE'NIUS, noun [Latin from the root of gigno; Gr. to beget.]*
> *1. Among the ancients, a good or evil spirit or demon supposed to preside over a man's destiny in life, that is, to direct his birth and actions and be his guard and guide; a tutelary deity; the ruling and protecting power of men, places or things. This seems to be merely a personification or deification of the particular structure or bent of mind which a man receives from nature, which is the primary signification of the word.*
> *2. The peculiar structure of mind which is given by nature to an individual, or that disposition or bent of mind which is peculiar to every man, and which qualifies him for a particular employment; a particular natural talent or aptitude of mind for a particular study or course of life; as a genius for history, for poetry or painting*

3. Strength of mind; uncommon powers of intellect, particularly the power of invention. In this sense we say, Homer was a man of genius Hence,
4. A man endowed with uncommon vigor of mind; a man of superior intellectual faculties. Shakespeare was a rare-genius.
5. Mental powers or faculties. [See No. 2.]
6. Nature; disposition; peculiar character; as the genius of the times.

Perhaps Webster had some motivation to do such a complete job with this word. His mind was certainly peculiarly suited for this particular task, and his "uncommon powers of intellect" and "vigor of mind" had helped him create what became the second most popular book ever printed in the English language.

It must have been soothing to know that his countrymen finally gave him the approval that he had sought, and praise for his work became nearly universal. But he would have done the work even without that approval, and he remained the same angry reactionary he always was, telling a friend, "We deserve all our public evils. We are a degenerate and wicked people." Then, in late 1830, he accompanied the son of his old friend Oliver Ellsworth, William, to Washington. Ellsworth had been elected to Congress, and Webster joined him to lobby for better copyright laws.

He was rewarded with more than just the copyright law. As one of the founders of the nation, he dined with President Jackson, who he actually despised, and many members of Congress, though he avoided festive gatherings whenever he could. But the real reward came when almost every senator, congressman and judge told him that they had "learned how to read in my books." Chief Justice John Marshall told him what a triumph his dictionary was, too, just for good measure. He had taught the nation its own language and would continue to teach it as the decades and centuries passed. It was something no one even knew we needed, and this prideful, tenacious, bad-tempered man had given it to us. It is a gift that keeps us together still.

Chapter 6

PRUDENCE CRANDALL

HEROIC EDUCATOR

With a name like Prudence, no one would have predicted that sweet Miss Crandall the schoolteacher would be a heroic rebel. But when we are confronted with an ethical choice, sometimes we find a strength we never knew.

Born in 1803, Crandall was brought up in the Quaker faith, learned frugality and hard work and received the best education a woman could possibly get in early nineteenth-century New England. After school, she took a job in Plainfield, Connecticut, and soon the wealthy citizens of nearby Canterbury initiated a school with young Prudence as the star teacher. Her parents and sister had recently moved there, too, and so she had her work and family all in one spot. The village green stood at the crossroads of the Norwich-Worcester and Hartford-Providence turnpikes, and an 1805 house on one corner had just been vacated. This became Miss Crandall's school for young ladies. In November 1831, when the doors officially opened, girls from distant towns applied and lived on site as boarders. This was a fairly radical idea, and there were only a few such schools in America. Catharine Beecher had just opened the first school for girls in Connecticut in 1823. Education for women was simply not believed to be necessary or desired.

Mariah Davis, a "colored girl" who helped out at the school, had a subscription to William Lloyd Garrison's abolitionist newspaper, the *Liberator*, and loaned a copy to her boss. Crandall's Quaker upbringing had already predisposed her to abhor slavery, and this reading inspired her to do something about it. What could she, a schoolteacher, do? "Shall I be inactive

and permit prejudice, the mother of abominations, to remain undisturbed? Or shall I venture to enlist in the ranks of those who with the Sword of Truth dare hold combat with prevailing iniquity?" she said. "As wealth was not mine, I saw no other means of benefiting them than by imparting to those of my own sex that were anxious to learn all the instruction I might be able to give, however small the amount." She made that choice and admitted a young black woman from the Canterbury church named Sarah Harris.

Small-town life can be idyllic—as long as you don't step out of the normal rules of behavior. Some students, or rather their parents, threatened withdrawal from the school, even though they had not objected to Sarah Harris or to any of the dozen families living and going to church in Canterbury with them all these years. They expected Miss Crandall to regret or at least reconsider her decision to admit a "colored" student. But she had an ace up her sleeve. She wrote to William Lloyd Garrison and asked a few other trusted people whether she could simply change her admission policy entirely and open a school for "young ladies of color." Captain Daniel Packer, one of the trustees, was sympathetic to this idea but was "troubled about the result" and predicted she would "injure" herself.

An advertisement appeared in the March 2, 1833 issue of the *Liberator*, inviting qualified applicants to "a High School for young colored Ladies and Misses." Crandall had not just crossed the line now; she had galloped over it. The other "trustees" and town worthies tried to talk her out of this plan, citing the objection that having so many colored students in town was sure to lead to "racial intermarriage." This racist and sexist attitude held no water with Crandall, who didn't try to rebuff the possibility but instead replied that "Moses had a black wife." The town gathered everyone— that is to say, white men—at a town meeting to decide what to do. As a woman, Crandall was "regrettably" not allowed to attend. She did have a few supporters, though, and the Reverend Samuel May and Andrew Judson, former friends, came down on opposite sides of the issue, with Judson bringing up all the old objections of declining property values, "foreign" interference and "mongrelization." May gave a rebuttal to this, and a defense of Crandall, but he and a Quaker named Arnold Buffum were at last run out of the meeting.

Crandall decided to reopen as an all-colored school, building up to twenty-four out-of-state students who boarded with her. She was promptly boycotted by nearly everyone. Local stores wouldn't sell her supplies. Even local doctors wouldn't provide service. Students were harassed in town, pelted with rotten eggs, chicken heads and stones. Manure was dumped

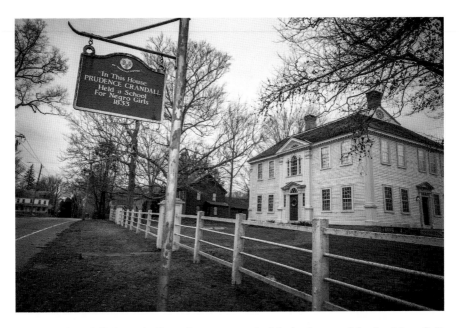

Prudence Crandall's house in Canterbury was attacked during her stand for the rights of all races to have equal access to education. *Photograph by Winter Caplanson.*

into the well. Worse, the state legislature passed a bill banning "any colored person who is not an inhabitant of any town in this State" from attending school in the state without special permission. Then, a letter from Judge Rufus Avery was sent to the sheriff of Windham County and the constables of Canterbury citing a law preventing "out-of-state" students from attending a school without permission. If Providence-born Eliza Ann Hammond did not leave immediately, "such person shall be whipped on the naked body not exceeding ten stripes, unless he or she depart the town within ten days next after sentence is given." The brave girl declared she was willing to take the punishment for the sake of the cause.

It wasn't just a small-town issue anymore. As Samuel May wrote, "The question between us is not simply whether thirty or forty colored girls shall be well educated at a school to be kept in Canterbury; but whether the people in any part of our land will recognize and generously protect the 'inalienable rights of man,' without distinction of color." William Lloyd Garrison visited and wrote more about the situation in the *Liberator*. The abolitionists of Boston fêted Crandall; the people of Canterbury burned her in effigy.

On June 27, 1833, things came to a head when a sheriff walked into Prudence Crandall's house and put her under arrest. In front of two judges

from Canterbury, she was arraigned to stand trial in nearby Brooklyn and was put in jail to await bond. But she did not post it, and soon even the men who arrested her realized that she had no plans to do so. This modest twenty-nine-year-old woman was now sitting in the town jail, an embarrassment for them and a beacon for others. A friend offered to post it for her, and she refused. "O no, I am only afraid they will *not* put me in jail," she replied. Her friend Mary Benson stayed the night with her, and the next day she left, the point being well made, the story of the dastardly jailing of a harmless schoolteacher already sweeping around eastern Connecticut.

The case moved through the courts slowly. Someone set a fire within one of the walls of the school, and the flames were only just discovered before the building burned down. A "mixed" black and white cat was left with its throat cut impaled on a fence post. Crandall was represented by William Ellsworth, son of the trailblazing lawyer and chief justice of the Supreme Court, and he argued that the law in question was unconstitutional. "A distinction found in color, in fundamental rights, is novel, inconvenient, and impracticable," he said. "Such were not the ideas of our fathers, when the colored soldier stood in the ranks of that army which achieved for us our liberty." Finally, in July 1834, the state's Supreme Court threw out the lower court's rulings on a technicality, granting victory to Prudence Crandall and her school.

She had won in court but not in the court of public opinion. There were more rocks thrown, more poisons dumped into the well. Then on September 9, 1834, a mob of club-wielding townspeople attacked the schoolhouse on the edge of the green, smashing windows and terrorizing the girls within. Crandall decided that she did not want to put her students' lives in any more danger and closed down. Soon afterward, she left Connecticut, never to return.

But she had not failed. Everyone else had. This fact became clearer and clearer as the next decades passed, leading to the Civil War. By that time, many more people in Connecticut were willing to take a stand for injustice and even risk their lives to end slavery. Decades later, Connecticut author Mark Twain and the shamefaced citizens of Canterbury were able to procure Crandall a small pension to keep her in her old age. She was living in Kansas and refused Twain's kind offer to buy the old schoolhouse for her retirement. Though life had presented her with many other challenges, she still held fast to her old work, telling a newspaper reporter in 1885, "The aspirations of my soul to benefit the colored race were never greater than at the present time. I hope to live long enough to see a college built on this farm, into which can be admitted all the classes of the human family,

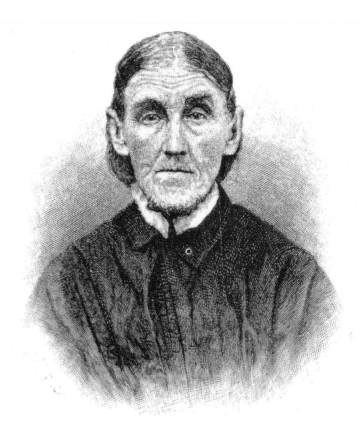

Throughout her life, Prudence Crandall worked for the benefit of all people. When asked if she had any regrets, the aging teacher exclaimed, "I have no time to waste, no time to spend in grief." *From the* Century Magazine.

without regard to sex or color....I want professorships of the highest order....You see that my wants are so many, and so great, that I have no time to waste, no time to spend in grief."

Education is not for members of a selected gender or race; it is for all. Crandall did not live to see the results of this expansion of equality, but she made one of the first efforts toward that goal. It can be a lonely road, with voices whispering from the bushes: "be safe," "be successful," "be comfortable." When the time comes for our own difficult road, let's hope we find the strength and wisdom of this Connecticut schoolteacher. Let's hope we make the right choice.

Chapter 6

CHARLES GOODYEAR

INGENIOUS INVENTOR

Born on December 29, 1800, Charles Goodyear was a descendant of one of the founders of the New Haven Colony, and his more immediate family still lived on New Haven's Oyster Point. But soon after his birth, they moved to the town of Salem, later called Naugatuck, where his father was a farmer and blacksmith and at one point started a short-lived button-making business. Indeed, it seemed like everyone in Connecticut was starting a small factory or shop in those days. Young Charles was given an education at a local school before being sent for tutoring to Reverend Daniel Parker in the Litchfield Hills for a more spiritual education.

However, the life of a minister was not for him. At age seventeen and only a smidge over five feet tall, he apprenticed to an importer of English hardware in Philadelphia but became sick and returned home. Still, he had learned the trade, and shortly afterward, he and his family opened the competing Goodyear and Sons store in Philadelphia, selling hardware made in their Connecticut shop. They announced their "Made in America" brand, to compete with the imports from England. Charles gave up smoking and drinking, dedicating himself to a Puritanical zeal for business. He married Clarissa Beecher in 1824, and she soon learned to be patient while listening to his constant flow of ideas.

For a while, this store was a success. But in 1829, the business started to fail, and by 1830, they were in debt. The Goodyears found that the problems Revolutionary governor Jonathan Trumbull had encountered in collecting debts had not yet been solved a lifetime later. Being the

middleman was still dangerous. By 1833, they had gone too far downhill to ever get up again. Charles was already deep in debt, and he was only thirty-two years old.

He turned to the miracle substance of the day, rubber, which seemed to hold promise if anyone could make it behave properly. In fact, there were several rubber companies already in the United States, but no one could quite transform this milky oozing "latex" from South American trees into a practical product. You could coat other things with this goop, like a cape or bucket, and make them mostly waterproof, but other than rubber balls and "chewing rubber," no one had figured out how to use it properly. Besides, it stank and melted in hot sun, causing angry consumers to return rubber products at a fantastic rate.

Goodyear rented a cottage in New Haven and turned the small upstairs into his laboratory. In a shed in his small yard, he mixed the rubber and turpentine in a tub, softening it, and then kneaded the sticky mass with his hands, spreading it out flat. He then tried to mix it with various chemicals and substances, trying to get rid of its stickiness, its smell and its vulnerability to heat. He glazed it, imbued it and engulfed it, trying additives like powdered magnesium and quicklime. At one point, he ordered casks of the raw sap and simply dipped a pair of pants in this liquid. But while wearing them in front of the fire, he literally gummed fast to a chair.

The same problems others had encountered kept assailing him. His hands were covered in the stuff. It stuck into his fringe of beard. His clothes smelled. Clarissa had to pawn their belongings to pay for her husband's obsession, making him a joke among the good folks of New Haven and a subject of pity from friends and family. "I have pawned my last silver spoon to pay my fare to the city," he told one companion.

Somehow, he convinced investors to back him in buying the failed Roxbury, Massachusetts rubber factory. But he was soon kicked out and spent the next few years renting space in various factories, using their ovens and other equipment. He got a contract to make waterproof postal bags, but after two weeks, they decomposed. So did an order of life preservers, a much more serious problem. At last his wife, father and brother were fed up and tried an intervention. Who can blame them? Three of his children had died already—would they have lived if their father made a normal living and provided for his family? He could have just been another of the millions who became obsessed by some idea only to waste their lives on fantasy. He didn't pay attention to their criticism, though, because he "became intently engaged with other another experiment."

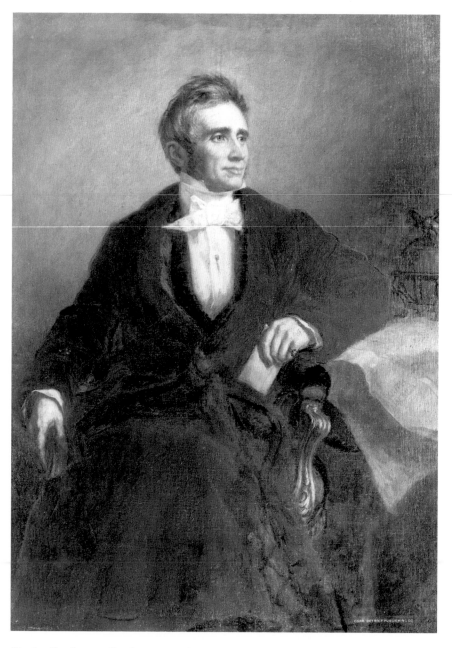

Charles Goodyear suffered poverty and poison before finally achieving the vulcanization of rubber. *Library of Congress.*

By 1839, acid and sulfur seemed to hold the key, though adding yet more odorous substances seemed to be counterintuitive. Then while experimenting with sulfur-treated pieces on an open fire, he found that instead of melting, the rubber had "perfectly cured." He worked on duplicating this process, building his own special heater and fiddling with temperatures. His daughter Ellen spoke of this period of discovery:

> *As I was passing in and out of the room, I casually observed the little piece of gum, which he was holding near the fire, and I noticed also that he was unusually animated by some discovery....He nailed the piece of gum outside the kitchen door in intense cold. In the morning, he brought it in, holding it up exultantly. He had found it perfectly flexible, as it was when he put it out.*

What he had done was to take the slippery molecule chains of rubber and cross-linked rings of sulfur, creating durable three-dimensional covalent bonds when super-heated. Goodyear didn't know these technical terms, but through trial and error, he had discovered an effective combination. Rubber could be a practical substance after all.

But the eureka moment did not immediately lead to success; he had to replicate the process consistently. While creditors hounded him, he pawned his children's schoolbooks for five dollars. He was arrested in Boston for failing to pay one debt, and his few remaining friends had to bail him out, while others despised him for "ruining" his family, who lived mostly on potatoes. But through all of it he remained, as he said, "merry as a cricket." By all accounts, he was single-minded and careless, with an incredible sense of personal entitlement.

His father and brother's family abandoned Charles's rubber obsession, moving to Florida and trying to import pineapples. All of them died of yellow fever. After mourning, he pressed on, getting better at the process, learning how to weave rubber onto textiles, forming strong suspenders, something he could actually sell. He found that white lead, sulfur and rubber heated at about 270 degrees resulted in a compound that no longer melted in the heat or even dissolved in turpentine. He called this process "vulcanization."

By now, Goodyear suffered from extraordinarily painful joints. A half century later, industrial scientist Alice Hamilton could have told him what it was, but no one in the 1840s knew about lead poisoning. He soldiered on, taking his wares to the 1851 Great Exhibition at the Crystal Palace in England. In his booth on the second level of the northeast gallery, apart

from other Americans, he demonstrated the incredible versatility of his new product, with rubber furniture, balloons, boxes, eyeglasses, buttons, cones, combs and, yes, even rubber plants. It was a big hit, and the competing English firm of Macintosh could only fume in helpless rage as investors and factory owners lined up outside the rubber walls of the booth to pay homage to Goodyear's discovery.

Back in America, he patented the process, a new protection that would have helped his Connecticut predecessor Eli Whitney in the 1790s. He and his investors formed the Naugatuck India Rubber Company in his old hometown, making dozens of products using his vulcanized rubber. This process had its own challenges, of course, requiring the purchase and creation of huge machine tools and molds. He also licensed the process to other factory owners like Leverett Candee in Hamden, who made the rubber-soled shoes that would soon become the most popular footwear in the world.

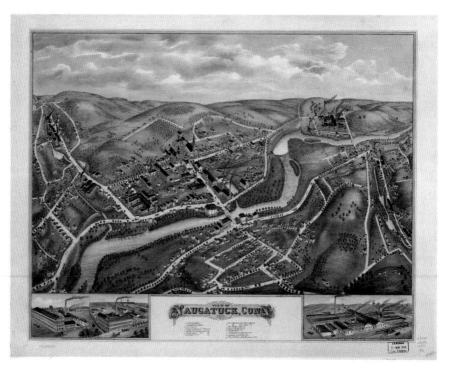

Goodyear's hometown of Naugatuck grew around his factory, but the tire company that bears his name today is unrelated. *Library of Congress Geography and Map Division, Washington, D.C.*

Although he was far from rich, finally profits from his factory and the licenses pushed his family out of debt. It did not seem to bring him happiness—he continued to rant and rave about his obsession. His face turned yellow, his hair receded and his eyes sank into his skull. Insomnia led to new ideas: pontoon boats, rubber breast pumps, rubber water beds. Life preservers and other flotation devices were among his proudest creations. "Most men continue to be drowned because their fathers were!" he said, showing ship captains his lifesaving products. He was also generous, giving money and gifts to friends, family and strangers. It wasn't money he was after; it was something else entirely.

Still, he had to protect his invention and his name. People like Thomas Hancock of Macintosh in England and Horace Day in Massachusetts tried to steal his product and discredit him. The American case against Goodyear's supposed licensing monopoly went to trial in Trenton, New Jersey. Lawyer Rufus Choate took the side of Horace Day, with the famous orator Senator Daniel Webster defending Goodyear. Webster described the misery of the Goodyear family in excruciating detail, focusing on his long-suffering wife, Clarissa, and the indignations and ridicule received from friends and strangers alike. He built up to the recent success, pounding the point home in his powerful voice:

> *And now is Charles Goodyear the discoverer of this invention of vulcanized rubber? Is he the first man upon whose mind the idea ever flashed, or to whose intelligence the fact ever was disclosed?...Is there a man in the world who found out that fact before Charles Goodyear? Who is he? Where is he? On what continent does he live? Who has heard of him? What books treat of him? Yet it is certain that this discovery has been made.*

After a long deliberation, the judges found for Goodyear, whose licensing process was safe for the moment. But more than that, Webster's rhetoric at the trial had bequeathed a sort of immortality on the Connecticut inventor, and his name began to appear in history books soon afterward.

But there was to be no happiness for Clarissa, who died of a stroke a year later in 1853. Goodyear remarried and was soon able to turn back to his other true love, rubber. He took his rubber products on a sales trip to Europe, though his rheumatic, gout-like pain returned with a vengeance. In Paris, he exhibited his wares at Napoleon III's exposition and received the Cross of the Legion of Honor. But he was also thrown in prison briefly for

debt when the French courts ruled against his patent attempt. He fled the country soon afterward.

In America, there was no respite, either, as more legal suits appeared, with person after person incorrectly claiming credit for the invention or more often correctly claiming that they were owed money. In May 1859, he moved to Washington, D.C., to be close to the patent office, knowing that people were trying to squeeze new developments in the vulcanization process by him. Then word came from New Haven, where his thirty-two-year-old daughter Cynthia was dying. Trying to reach her bedside, Goodyear took a steamboat up the coast but only made it to New York before learning that she was already dead. He collapsed and had to be hauled on a cart to a hotel on Fifth Avenue. As he lay on his deathbed, his family and friends told him he could rest certain of his own achievements. "What am I?" he said before dying. "To God be all glory."

Though it seems that at the end Charles Goodyear rejected the immortality he had sought for so long, he was too late in this denial. "The wonders of the day explode," he said once. "And are never heard of afterwards." He had spent his health pursuing a genuine world-changing invention, one that would transform human life, and he achieved his place in history. He will be remembered forever, or at least as long as rubber meets the road.

Chapter 8

P.T. BARNUM

VISIONARY SHOWMAN

When Phineas Taylor Barnum was four years old, his namesake grandfather, Bethel's most prominent wag, told him that he would soon inherit a beautiful piece of land outside town called Ivy Island. For the next eight years, grandfather encouraged grandson, telling everyone that he was "the richest child in town" who owned "the most valuable farm in Connecticut." The boy believed every word and assured "worried" neighbors that he would still play with their children once he inherited this "immense wealth." Finally, at age twelve, the day came when he was shown his kingdom. A long hike into a muddy bog ensued, with the child becoming more and more suspicious as he was attacked by hornets and nearly drowned in the mire. At last they emerged on "Ivy Island," a tiny piece of barren land in the middle of the swamp. Slowly it dawned on him that the entire town, including his parents, had been in on his grandfather's long-running practical joke.

There were several lessons to be learned in that early experience, and P.T. Barnum absorbed them all. Refusing farm work, he took a job as a clerk in the Bethel store, traveling to New York to better learn the trade and then opening a fruit and confectionary store with his mischievous grandfather. He learned how to sell people things they didn't need and how not to be conned himself. Exploiting a loophole in the state's strict laws, he set up lotteries, which yielded a sizable profit. He started his own newspaper, the *Herald of Freedom*, figuring that was the best way to promote his moneymaking schemes. And in doing so, he was jailed for libel in nearby Danbury. The

same judge who ruled against Prudence Crandall and denied free blacks citizenship oversaw this case, ruling against free speech and putting Barnum in jail for sixty days. But this minor martyrdom only increased subscriptions to the newspaper. On his release, a parade of sixty carriages, forty horsemen and a marching band ensued, with supporters praising his triumph all the way to Bethel.

He had learned the next lesson of his young life: the power of spectacle. He resolved to give up the life managing a country store and go on the road. He heard a story of former slave Joyce Heth, who supposedly was 161 years old and had nursed George Washington. He found her and signed on as her manager, arranging exhibitions throughout the Northeast, learning the trade of advertising and publicity. Heth was blind and partially paralyzed but talked a great game, answering questions about "dear George" and singing plantation songs. They toured until February 1836, when she died and a doctor pronounced her no more than 80 years old. The *New York Sun* called it "one of the most precious humbugs that ever was imposed upon a credulous community." But Barnum had learned another valuable lesson, that placing just enough doubt in the public's mind was enough to bring them to a show. If she was a fake, he said, how was she so familiar "with the minute details of the Washington family?"

A series of other jobs as promoter and manager followed, including one with the Old Columbian Circus. In 1842, he rented the "Feejee Mermaid," a taxidermy-shop creation of half-fish, half-monkey, and filled the newspapers with talk of the upcoming exhibition of this "mermaid," finding out that he could get free publicity with some well-placed rumors. He also figured out how to plant objections or charges against himself in the newspapers, a simple ruse to gain more publicity. Using another name, he accused a bearded lady at his own museum of being a man. Doctors were called, and the "examination" yielded huge publicity, especially after it proved she was indeed a woman.

When he had enough money, he bought Scudder's American Museum, which included collections of natural wonders, paintings, inventions and other curiosities. He added more live exhibits, including exotic animals, "natives" of various sorts and "giants." He introduced concessions and ice cream stands, as well as taxidermists, fortunetellers and even glassblowers. And then, stopping at his half brother's hotel in Bridgeport, he met "the smallest boy alive," Charles Stratton. The four-year-old was only twenty-five inches high and had, in Barnum's words, "fresh, rosy cheeks, large beautiful dark eyes, a fine forehead, a handsome mouth, and great vivacity

of expression and hilarity of manner." With Barnum's help, he quickly blossomed into a talented singer, dancer and comedian. Unlike the Feejee Mermaid or Joyce Heth, Charles was not a hoax. Barnum used this to his advantage, and when people showed up to see "General Tom Thumb," they were always pleasantly surprised.

Once "the General" had conquered America, Barnum took him to Europe, where he continued to improve his methods. Once he understood England's class system, Barnum rented a prominent home and invited aristocrats and politicians to visit "the celebrated American dwarf." They took the bait, and soon the palace came calling, with Queen Victoria desiring "to see him act naturally and without restraint." Barnum put up a prominent sign: "Closed for the evening, General Tom Thumb being at Buckingham Palace by command of her Majesty." His performance was a resounding success, especially when he backed out of the gallery at the end and the queen's tiny spaniel barked and nipped at him. He held his small cane like a sword, and the mock battle was "one of the richest scenes" the onlookers ever saw. The queen had given her stamp of approval, and now every English citizen wanted to see the act, along with every other royal

P.T. Barnum's protégé Charles Stratton's mock battle with Queen Victoria's spaniel became comedy legend. *From Barnum's* Struggles and Triumphs, *Magnus Wahlstrom Library, University of Bridgeport.*

in Europe. Both performer Charles Stratton and impresario P.T. Barnum were huge hits among the rich and poor alike and continued their triumph throughout Europe.

One of the greatest promotional tools Barnum came up with during this tour was to craft a miniature coach for General Tom Thumb and, with ponies instead of horses, have it driven through town before a performance. He claimed it would "kill the public dead….It will be the greatest hit in the universe, see if it ain't!" And of course, he was right. Charles Stratton used this carriage trick for forty years, and the sight of this tiny man waving from the window never failed to draw a crowd.

Barnum was also involved in the "joke of the century" when his protégé, dressed up as Napoleon, met the Duke of Wellington, who had defeated the Frenchman only a few decades earlier. The duke saw Charles sitting morosely and asked him what was wrong. "I was thinking of the Battle of Waterloo," he said, drawing a huge laugh from everyone there. Charles continued to mimic Napoleon for forty years, and today our image of the great general comes not from reality, since Napoleon was a healthy five feet, eight inches, but from the clever impersonation taught to this little "general" by Barnum.

Back in America, Barnum continued to expand his reach, discovering that the increasing use of trains and steamboats could provide safer and faster travel than the "diligence" coaches he had been forced to use in Europe. Tom Thumb's and later Jenny Lind's tours became whirlwinds compared to the ones before them, the first to take advantage of these new technologies. Barnum would later suggest to Charles that he and his troupe complete the first "round the world" tour, and they did, becoming the first celebrity entertainers to do so, performing in Japan, Australia, India and Egypt.

There were other new technologies to exploit, and Barnum figured out how to make great use of them all. The telegraph allowed him to "call ahead" to towns on tour and to put advertisements into local newspapers ahead of events. Newspapers themselves were being mass produced all over America and Europe, and he pioneered advertising techniques like adding favorable reviews the following day, in order to encourage people who missed it to take the train to the next show. He spent the extra money for pictures and for other innovations in printing, knowing that the expense would draw twice the money later. The new art of photography became a tool for creating new kinds of souvenirs, allowing people to "take home" pictures of their favorite performers. Coins, drawings and other trinkets were mass produced for the American Museum and his traveling shows in numbers never seen before.

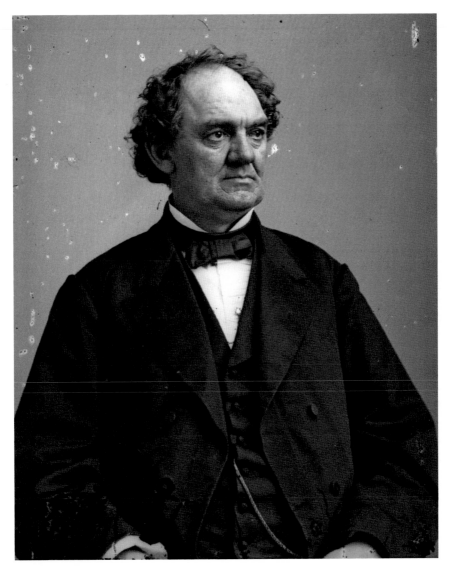

P.T. Barnum pioneered methods of advertising and promotion that are still used today. *Photo by Matthew Brady. Library of Congress.*

His most successful single enterprise was managing the American tour of "Swedish nightingale" Jenny Lind. She had been convinced to hire Barnum when she saw a picture of his incredible Bridgeport mansion, Iranistan, the largest and most opulent palace in America and a marketing tool on its own. Barnum had already turned to showing "morality plays" in his museum, and

so the irony of this "huckster" promoting the very modest, innocent Lind did not seem so ironic to most of the public. He used all his skills of preparation, organization and promotion to make sure every aspect of the tour was effective. And it was, making huge amounts of money for both Barnum and Lind as she sold out concert halls in every major city, performing in front of Daniel Webster, President Millard Fillmore and the entire Supreme Court.

It seemed that no one could resist Barnum's hype—not even the man himself. In a fit of overconfidence, he invested in a clock factory and took on too much debt, nearly bankrupting himself. He promptly wrote a book called *The Art of Money-Getting*, which, along with a supporting lecture tour, made him almost enough money to pay off the creditors. His protégé Charles Stratton helped him with the rest. When Charles met another of Barnum's performers, Lavinia Warren, they fell in love, and the subsequent marriage became the event of 1863, knocking the Civil War off the front pages of the newspapers. Of course, Barnum used it as a promotional opportunity and drew thousands upon thousands of visitors to the American Museum.

After the war, he ran for and won office in the Connecticut legislature, particularly to vote on the state's constitution and universal suffrage. He gave a speech that electrified his colleagues, saying, in part, "A human soul is not to be trifled with. It may inhabit the body of a Chinaman, a Turk, and Arab, or a Hotentot—it is still an immortal spirit!" Although he loved what he called "the art of humbug," he considered it only appropriate for entertainment and despised when politicians or spiritualists used it to bilk money out of others. In his public pursuits, he remained a classic reformer, trying to use power and money to help others. When he became mayor in 1875, these reforming ways got him in trouble when he tried to enforce liquor laws, shut down brothels and investigate corruption. The citizens of Bridgeport voted him out as quickly as they had voted him in.

As his curly hair receded and turned white, Barnum went on to more struggles and triumphs. Fire had destroyed his first mansion in the 1850s, and soon it took the American Museum. He remarried late in life, trying to find happiness in domestic and civic life in Bridgeport. His investments in real estate were divided into lots and parks under the Olmsted model. The second-largest landholder in town, he even laid new sewer pipes, constructed water mains and created fifty-eight thousand square feet of sidewalk. He built a recreation hall, contributed money toward the Bridgeport Hospital and served as president of the Bridgeport and Port Jefferson Steamboat Company. He was even the first official member of the Bridgeport Public Library in 1882.

Unable to keep from his passion for entertainment, he started yet another circus, adding "rings" and soon joining with competitor James Bailey to create "the greatest show on earth." Circuses had never been profitable ventures, but Barnum's improvements made them the height of entertainment for the next half century. Bridgeport's enormous complex of the circus Winter Quarters became the largest animal-training facility in the world, with 150 permanent employees, a dozen workshops and its own steam power plant and 350-foot Railroad Building, which held one hundred circus cars and wagons. Excited children peered through the fences or stared at the elephants taking baths in Long Island Sound.

By the late 1880s, he had succeeded beyond his wildest dreams, and the disappointment he had felt when not inheriting "Ivy Island" had faded appreciably. His friend President James Garfield called him the "Kris Kringle of America," and another friend, Ulysses S. Grant, told Barnum just before he died that wherever he went on his travels around the world, "in China, Japan, the Indies—the constant inquiry was 'Do you know Barnum?' I think, Barnum you are the best-known man in the world." His name had become synonymous with capitalism, gumption and even America itself. The *New York Herald* called him the "man of the future," who "feels it, sees it rushing up to us."

All the various forms of entertainment Phineas Taylor Barnum engaged in were thousands of years old. He did not invent the circus or the museum or stand-up comedy. But more than anyone before or possibly since, he figured out how to sell them to the public, using the latest technology, the art of rhetoric and the desires of the public. "The noblest art," he said, "is that of making others happy."

Chapter 9

HARRIET BEECHER STOWE

AUDACIOUS AUTHOR

Born in 1811 in Litchfield, young Harriet Beecher experienced the town's golden age, when it was the fourth largest in the state and buzzing with schools, businesses and political action. Her home on North Street swarmed with relatives and boarders, including students from Sarah Pierce's nearby Female Academy. Her father, Lyman Beecher, was Litchfield's minister, and her mother, Roxanna, taught school and gave birth to an astonishing eleven children, all of whom lived to adulthood. Along with Harriet, they included Catharine, who grew up to be a famous educator, and Henry Ward, who grew up to be a famous abolitionist preacher.

However, Harriet would become the most famous of them all, as the author of one of America's most important novels. Her childhood in Litchfield instilled her with a strong sense of family and a commitment to others, as well as a fascination with writing. Recalling her father's library, she said:

> *Here I loved to retreat and niche myself down in a quiet corner with my favorite books around me. I had a kind of sheltered feeling as I thus sat and watched my father writing, turning to his books, and speaking from time to time to himself in a loud, earnest whisper. I vaguely felt that he was about some holy and mysterious work quite beyond my little comprehension, and I was careful never to disturb him by question or remark.*

Roxanna died when Harriet was only a girl, but her spirit continued to animate her daughter's writing for the rest of her life.

Harriet began writing at her Litchfield home and at her grandmother's farm Nut Plains, near Guilford. At age twelve, she wrote award-winning essays on questions of the fate and the soul, such as "Can the Immortality of the Soul Be Proved by the Light of Nature?" When she heard a reading of the Declaration of Independence, she stirred even more toward public action through writing. "I was as ready as any of them to pledge my life, fortune, and sacred honor for such a cause....It made me long to do something, I knew not what: to fight for my country, or to make some declaration on my own account."

Harriet also absorbed her father's preaching, locating her religious awakening on a "dewy, fresh summer morning" in Litchfield, a Sunday when she was just fourteen. When her father began to give a sermon, she was "drawn to listen by a certain pathetic earnestness in his voice." Later that day, she went into her father's study and declared herself: "I have given myself to Jesus, and He has taken me." She also gained an unreserved confidence in love: "There is a heaven,—a heaven,—a world of love, and love after all is the life-blood, the existence, the all in all of mind."

Her father accepted the presidency of Lane Theological Seminary in Cincinnati in 1832, and Harriet joined him in Ohio. She had her first experiences with slavery when she traveled across the border to Kentucky, witnessing things that she described later in *Uncle Tom's Cabin*. At that time, the city had become a flashpoint for the abolition movement, and a mob attacked her father's seminary. Harriet lamented, "Pray what is there in Cincinnati to satisfy one whose mind is awakened on this subject? No one can have the system of slavery brought before him without an irrepressible desire to *do* something, and what is there to be done?"

She married widower Professor Calvin E. Stowe in 1836, and they had twin girls and a son over the next two years. The family helped at least one freed slave to safety, after learning that her former owner was trying to take her back. They also lived near a number of liberated slaves, including Aunt Frankie and Eliza Buck, her cook, whose stories helped give Harriet a sense of what life was like for slaves.

After returning to Hartford in 1842, she decided to devote herself completely to writing. Her husband told her, "My dear, you must be a literary woman. It is so written in the book of fate....Drop the E. [middle initial] out of your name....Write yourself fully and always Harriet Beecher Stowe, which is a name euphonious, flowing, and full of meaning." Beecher Stowe she would be, and it was a name that would soon ring out from the lips of millions of Americans.

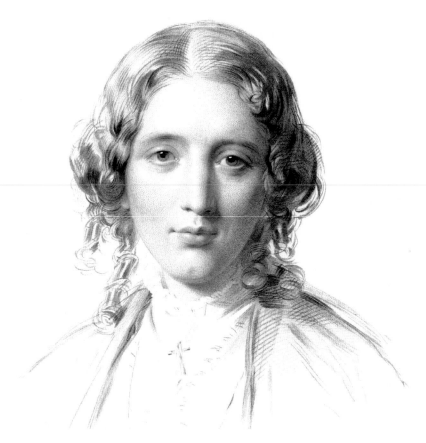

This portrait of Harriet Beecher Stowe by Francis Holl in 1853 shows a determined young woman ready to change the world. *From* Life and Letters of Harriet Beecher Stowe, *Magnus Wahlstrom Library, University of Bridgeport.*

In 1849, they moved to Maine, with a few more children in tow. A year later, one of the worst laws in the country's history, the Fugitive Slave Act, was passed. Beecher Stowe was furious; her "soul was all on fire with indignation." Particularly upsetting to her was the way families were broken up by slavers and the brutal way former slaves were tracked down and returned to bondage. Her brother Edward's wife urged her to write about slavery, telling her, "Now, Hattie, if I could use a pen as you can, I would write something that would make this whole nation feel what an accursed things slavery is."

In April 1851, Beecher Stowe completed the first chapter of *Uncle Tom's Cabin* and submitted to be published in *National Era* magazine. But the

novel wasn't finished, and she needed material, so she wrote to Frederick Douglass, wondering if he could put her in touch with individuals whose stories would help her "make a picture that shall be graphic and true to nature in its details." Writing her novel in front of the fire with children playing around her, she was able to speak "to the understanding and moral sense through the imagination...through a series of pictures." *Uncle Tom's Cabin* ran for almost a year as a serial in the *National Era* before being published as a book. The interwoven stories of slaves and families became an instant bestseller and won praise from writers like John Greenleaf Whittier and Henry Wadsworth Longfellow. The impact in the American North and Europe was profound, making "a series of abstract propositions" concrete. At one time, a London publisher estimated a circulation of one and a half million copies.

With seeming effortlessness, she wove the lives of vastly different characters from varied backgrounds, speech patterns and mannerisms. She was able to make each character representative of an American "type," but each also becomes real. The readers suffered along with slaves like Tom and Chloe but also sympathized with some of the slave owners, trapped in a system continually spiraling into violence and shame. More importantly, perhaps, readers were sickened by the cruelty and violence of other slave owners and of the system itself.

She toured Europe as a celebrity three times, but her appeals were directed most loudly to American women: "I do not think there is a mother who clasps her child to her breast who would ever be made to feel it right that that child should be a slave, not a mother among us who would not rather lay that child in its grave....For the sake, then, of our dear children, for the sake of our common country, for the sake of outraged and struggling liberty throughout the world, let every woman of America now do her duty." No one who read *Uncle Tom's Cabin* was unaffected, and when slave owners protested the book as being too harsh, former slaves avowed that it was much too mild.

She began writing her follow-up, *Dred*, in 1856, while dramatizations of *Uncle Tom's Cabin* for the stage brought her story to those who could not read. When her son Edward died in 1857, drowning in the Connecticut River, she turned again to writing for solace and motivation. In December 1858, the first chapter of *The Minister's Wooing* appeared in the *Atlantic Monthly* and *The Pearl of Orr's Island* appeared first as a serial in the *Independent*. Meanwhile, the rhetoric across the country became more and more heated, and the country split apart.

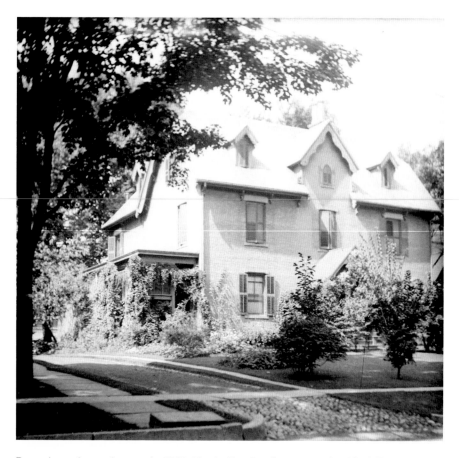

Returning to her native state in 1863, Harriet Beecher Stowe moved to Nook Farm, a vibrant community of writers, artists and activists. *Library of Congress.*

When the Civil War erupted, Beecher Stowe's son Frederick was one of the first to sign up, mustering with Company A of the First Massachusetts Volunteers. Almost two years later, Beecher Stowe met President Abraham Lincoln on Thanksgiving Day. He reportedly greeted her by saying, "So you're the little woman who wrote the book that started this great war." Perhaps only a legend, these understated words were not too far off the truth.

The family finally returned to Hartford, settling in the neighborhood of Nook Farm, an artistic community cradled in the "nook" of the winding Park River. Stowe was drawn to the mighty oak and chestnut trees and helped supervise the building of the house she would call Oakholm, completed in 1863. Ten years later, though, the family moved to the Gothic

Revival Victorian brick house on Forest Street across the lawn from the house occupied by her most famous neighbor, Samuel Clemens.

Her shelf of books continued to grow. *Oldtown Folks* was published in 1869, the same year she collaborated with sister Catharine on *The American Woman's Home*. In all, she authored thirty books, numerous short stories, letters, travel reports, hymns and articles for various magazines and journals. But none had the shattering impact of *Uncle Tom's Cabin*. She died in 1896 at Nook Farm in Hartford, after watching her husband and four of her seven children die. "I wrote what I did," she said, "because as a woman, as a mother, I was oppressed and broken-hearted with the sorrows of injustice I saw."

Harriet Beecher Stowe declared the power of literature and became the first American writer whose work impacted the entire country. In her hands, a fictional story brought real emotions, real changes of heart and real results.

Chapter 10

FREDERICK LAW OLMSTED

ORIGINAL LANDSCAPE ARCHITECT

When Frederick Law Olmsted was born in Hartford in 1822, the idea that towns or cities should have parks in them was not a common one. The Industrial Revolution had not quite taken firm hold of Connecticut yet, and young Olmsted could play in the woods and fields just a short walk from his home. His father took him on short rides through the scenic adjoining farmlands, what he called later "the root of all my good work." But by the time he died eighty years later, American cities had for the most part become choking, smog-filled hell holes, with only one respite: the parks he had envisioned and designed.

Olmsted was groomed to attend Yale College, but after a bout of sumac poisoning, his weakened eyesight convinced him to try other paths. He dabbled with becoming a clerk, a merchant seaman and a civil engineer before settling on a "scientific farmer." He learned some principles of agriculture and chemistry from Professor Benjamin Silliman at Yale, though he was not enrolled. Then, at age twenty-six, he bought a farm at Sachem's Head, in Branford, Connecticut, fixing the house, planting flowers in the yard and grading the land, seemingly more interested in how it looked than how it thrived. And it certainly did not thrive. Like many other prospective farmers in the Nutmeg State, he found the ground a bit on the rocky side. "I haven't dislocated my hips nor my right wrist nor my neck yet," he wrote, but continued, "Have [dislocated] all the rest."

His next attempt was on Staten Island, on a farm his father bought for him. However, it seemed he could not settle down and just farm; he had

to travel. He took an extended trip to Europe from April to October, one entire planting season. During the trip, though, he had the opportunity to see the great private estates of the nobility and remembered the "gracefully, irregular, gently undulating surface of close-cropped pasture land" when he found his true profession. He would bring in the "copper-leaved beeches" that he fell in love with there to nearly all his parks.

His personal life suffered from his travels, and he remained unmarried into his thirties. A brief romance flourished with Emily Perkins of Hartford, but she broke off the engagement and married the minister and abolitionist Edward Everett Hale. Olmsted turned to writing a travel book about his English adventures and continued writing articles in the *New York Times* after a visit to the southern slave states, fearlessly recording the terrible abuses and broken economy. He saw the free farmers of both North and South as victims of this system and believed that competition would eventually help bring about the end of slavery. He over-optimistically argued that once slave owners saw the advantages of free labor over slave labor, they surely would change their system.

He found some success as both writer and farmer but also studied aesthetics, gardening and agriculture in his spare time. He became enough of an expert in the field for architect Calvert Vaux to ask him to collaborate on a design, which they entered into a contest for the re-landscaping of New York's Central Park. They won, and he was also offered a job as the park's superintendent. Of this opportunity, he later wrote, "I was unexpectedly invited to take a modest public duty and from this by promotions and successive unpremeditated steps was later led to make Landscape Architecture my calling in life." It seems a strange thing for a genius to fall accidentally into his profession, and perhaps we can take Olmsted's statement with a grain of salt. After all, his training as an experimental farmer, his study of aesthetics, his travels to Europe and his management skills all helped make him successful at his design work.

He immediately put "a few short of one thousand men" to work re-landscaping the park, and a few months later, he had twice that. He also had to deal with personal tragedy; his brother John had died of tuberculosis, leaving his wife, Mary, and three children devastated. Olmsted promptly married her in 1859, and they had four children of their own. The following year, he and Vaux took on their next job, designing the grounds of the Hartford Retreat for the Insane. They began to call themselves "professional landscape architects," the first in the world, rejecting the term "gardening" for these epic scale projects, saying that it did not do justice to work that

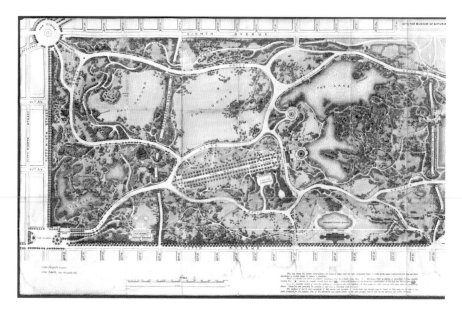

Frederick Law Olmsted's design for Central Park established his career as a "landscape architect," a title he helped invent. *New York Public Library Digital Collections.*

included "exposing great ledges, damming streams, making lakes, tunnels, bridges, terraces, and canals." Later that year, the two men were appointed landscape architects and designers of the Manhattan parks.

For the next several years, he parlayed his success designing Central Park into other jobs—as park superintendent, sanitary commissioner and even mining company consultant. His *Times* articles were published as *Journeys and Explorations in the Cotton Kingdom*, which now found a huge audience during the Civil War. However, he continued his design part time with Vaux, working on Brooklyn's Prospect Park. By 1863, he had strained both body and mind and traveled to California to rest and camp in Yosemite. He was promptly appointed by the governor as commissioner of Yosemite and Mariposa Big Tree Grove and was one of the first to suggest that it be turned into a public park.

This suggestion was part of a lifelong belief in the importance of public green spaces where all citizens could gather and enjoy the relaxing and healing powers of nature. He tried to create a sense of peace through nature in order to give city dwellers a place of healthful restoration. He wanted his parks to have an effect "like that of music" and to have "complexity of light and shadow." He wrote:

It is a scientific fact that the occasional contemplation of natural scenes of an impressive character, particularly if this contemplation occurs in connection with relief from ordinary cares, change of air and change of habits, is favorable to the health and vigor of men....The want of such occasional recreation where men and women are habitually pressed by their business or household cares often results in a class of disorders the characteristic quality of which is mental disability, sometimes taking the severe forms of softening of the brain, paralysis, palsy, monomania, or insanity, but more frequently of mental and nervous excitability, moroseness, melancholy, or irascibility, incapacitating the subject for the proper exercise of the intellectual and moral forces.

His focus on simplification and unification had its roots in English gardens but was taken further. According to his theory, all the elements of the landscape should be coordinated to create one experience for the people in the park. "Service must precede art," he said. "So long as considerations of utility are neglected or overridden by considerations of ornament, there will not be true art." He was composing the landscape into an integrated whole, or as he put it, "miles of scenery where cliffs of awful height and rocks of vast magnitude and of varied and exquisite coloring, are banked and fringed and draped and shadowed by the tender foliage of noble and lovely trees and bushes, reflected from the most placid pools, and associated with the most tranquil meadows, the most playful streams, and every variety of soft and peaceful pastoral beauty." He created picturesque scenery, with closely mown grass on gently rolling ground, as well as a jungle-like mass of shrubbery and trees on steeper areas. He wanted to give citizens "greater enjoyment of scenery than they could otherwise have consistently with convenience within a given space."

At age forty-three, he devoted everything to his design work, forming Olmsted, Vaux, and Company. They worked on parks in Chicago, Buffalo, Milwaukee and Niagara Falls. And he did not neglect his home state, designing Seaside Park and Beardsley Park in Bridgeport, Bushnell Park in Hartford and Walnut Hill Park in New Britain. This began a long catalogue of parks and other landscape jobs that he would continue for the rest of his life. Some would be entire systems of parks, like the one in Louisville, Kentucky. He also conceived of "parkways" to connect urban areas to these parks, something that would truly come to fruition in the twentieth century's automobile age. Designs for college campuses, government properties, cemeteries and even entire residential suburbs emerged from his pen, all

with a distinctive "Olmsted" look that incorporated the whole but did not forget the tiniest detail.

By 1883, he had established the first firm to focus solely on landscape architecture, in Brookline, Massachusetts. In addition, he urged preservation of natural environments, like Niagara Falls and Presque Isle, Michigan, stating that wonders like that "should not be marred by the intrusion of artificial objects." Furthermore, while most gardeners of his day focused on the new global availability of seeds, he tried to use native plants whenever possible and grounded his designs in the specificity of place. He had never forgotten the rural character of early nineteenth-century Connecticut, with its pleasantly spaced farms and old gardens,

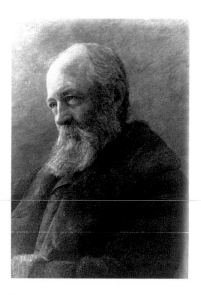

By the end of his life, Frederick Law Olmsted had changed the urban terrain of America. *Library of Congress.*

full of "interesting rivers, brooks, meadows, rocks, woods or mountains." Blended with the private deer parks of Europe, these landscapes now existed in small quantities at the heart of cities throughout America.

By the time of his retirement in 1895, he and his firm had created over five hundred different parks, an astonishing number for any artist. It is also a reminder of the good that can be accomplished when projects and commissions are given to someone who is a master of a craft. What makes it even more astonishing is that this craft of landscape architecture is one that he practically invented. Perhaps that was good luck for America, but it was probably no accident. If humans are going to live in giant anthills and pave the world with macadam, we need people to figure out ways to get us back into nature, to heal and renew our industrialized souls.

Few have had such a profound effect on the way that the world looks to us as Frederick Law Olmsted. His sons continued the legacy of his groundbreaking design firm, taking on thousands more projects, and his artistic heirs took on tens of thousands more. Today, his legacy can be found in every corner of the urban and suburban landscapes of America.

Chapter 11

EBENEZER BASSETT

DAUNTLESS DIPLOMAT

Ebenezer Don Carlos Bassett was born on October 16, 1833, in Litchfield, Connecticut, one of the most progressive places in America. A vast majority of African Americans in the state were free, owning property, farms and businesses. Still, there were limits. Though fewer than one hundred slaves remained, at least officially, slavery was still legal. African Americans could not vote and certainly were not treated as equals by most. And of course, they were lucky compared to those in other many areas of the country. In many places, racism was getting worse, not better, as slaveholders throughout the country spread propaganda, worried that their "peculiar institution" would slip away.

Bassett's great-grandfather Pero had been brought as a slave to Derby in the 1700s, but his son Tobiah had earned his freedom for serving in the Revolutionary War. Tobiah's son Eben married Susan Gregory Bassett and took her last name. Both Tobiah and Eben were "black governors," unofficial leaders of the local valley community. Soon after Ebenezer's birth, his parents moved back to Derby, and he grew up on a farm on the banks of the Housatonic at Great Hill. But the child's intelligence led him to work in the office of Dr. Ambrose Beardsley, who also acted as a tutor, introducing him to the sciences and the classics. This gave him, as he said in later years, "a fair chance to run his race in life."

With such an intelligent son and their position in the community, Ebenezer's parents were thus able to offer him a rare education. He attended the local Birmingham Academy before leaving for Wilbraham,

Massachusetts' Wesleyan Academy, the first coeducational boarding school in the country, and a stop on the Underground Railroad. He did so well there that he was able to transfer to New Britain's Connecticut Normal School in 1853, the first African American to do so. On his graduation in 1855, he addressed the audience with a speech called "The True Teacher." The state's schools had improved a little in the two decades since schoolteacher Prudence Crandall had her run-in with racial intolerance.

By now he had grown a full, fashionably curled mustache and was tall and slender. He got a job at the Whiting School in New Haven, and after just one year, according to the school board, he had "transformed 40 or 50 thoughtless, reckless, tardy and reluctant youngsters into intelligent ambitious, well-disciplined and well-behaved students." He took classes at Yale while he was teaching, learning languages like Latin and French, as well as brushing up on math and literature. He met New Haven girl Elizabeth Park, and they were married, a union that would last fifty-three years and give them eight children. When former slave Frederick Douglass came to town to give one of his famous speeches, young Ebenezer introduced himself. Douglass encouraged him to give something back to the community. They stayed in touch and soon became close friends.

In 1856, he was hired as a member of an all-black faculty at the Institute for Colored Youth in Philadelphia, becoming principal after just one year. For fourteen years, he worked hard to improve the quality of the school, starting a lecture series and becoming a political leader in the community. In 1863, just after the Battle of Gettysburg, Bassett was asked to speak at a gathering of free blacks in Philadelphia. The thirty-year-old Bassett stood up and spoke urgently of this "precious moment," saying, "For generations we have suffered under the horrors of slavery, outrage, and wrong; our manhood has been denied, our citizenship blotted out, our souls seared and burned, our spirits cowed and crushed, and the hopes of the future of our race involved in doubts and darkness." But now, "we will rise!" Perhaps he thought of his grandfather's service to Washington when he said, "We must rise up in the dignity of our manhood, and show by our own right arms that we are worthy to be freemen." Frederick Douglass was next to speak, and even he had trouble following Bassett's passionate entreaty.

After the Civil War, prominent African Americans were given positions in government and won seats in the Houses of Representatives throughout the country. To many, it looked like racial equality would soon be achieved. At the urging of friends, Bassett applied for the job of minister of Haiti on March 17, 1869, writing a letter to President Grant, saying in part that

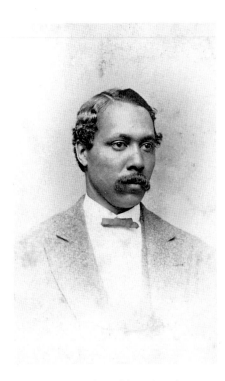

As the country's first African American ambassador, Ebenezer Bassett proved his worth through principled diplomacy. *Courtesy of Elihu Burritt Library, Central Connecticut State University.*

the appointment would be welcomed "by recently enfranchised colored citizens, as a marked recognition of our new condition in the Republic and an auspicious token of our great future." One of the many supporting letters to the State Department, from Thomas Webster, noted Bassett's ability to stop a "riot," a seemingly strange recommendation but one that would in fact become useful over the next eight years. A few weeks later, President Ulysses Grant warmly welcomed Bassett into the Oval Office, offering him a cigar and the job.

On May 25, 1869, Bassett arrived in New York City to take his ship. He had instantly become a hero to the black community, and a huge gathering was held at Shiloh Church to celebrate his appointment. He realized that he embodied the hopes of his people and felt the weight of that responsibility. A week later, he boarded the ship, saying, "I may fail in this mission, but I promise you this, an honest heart, a noble endeavor, and true patriotism." The entire audience erupted in applause and cheers.

Though independent since 1804, Haiti had only established a relationship with the United States since 1862 because the southern states had refused to recognize a former colony of ex-slaves. It was an important island for the United States, with its shipping lanes and naval coaling station, called "The Mole," which the governments of both countries would wrangle over for the next twenty years. On Bassett's arrival in Port-au-Prince, crowds shouted in a dozen languages to welcome this "curiosity," and at night, he was hailed by a different crowd of "mosquitoes, gnats, and bedbugs." He would soon get used to both, as well as the many duties of his new position of "minister general," the title they used for ambassador at that time. He needed to inspect ships' cargo papers, balance accounts, verify complaints, issue passports and

give emergency assistance to other Americans. In those days when a reply from Washington might take weeks, he had to make decisions on the spot. It was a good piece of work for a schoolteacher, but sometimes we are called on to do more than we think we can.

His job was made doubly difficult, since the people he oversaw were not used to taking orders from a black man, and he struggled to maintain the right balance of service without servility to both governments and peoples. Nevertheless, he was able to maintain not only a stable relationship between American and Haiti during all this but a stable home life as well, since his wife and children joined him in Port-au-Prince. In 1872, his daughter Charlotte was sixteen, Ebenezer Jr. was fourteen, Iphigenia was eight and Elizabeth was four. His wife, Eliza, was soon pregnant again, with a child they would name Ulysses after their presidential benefactor. She would bear two more children while they were in Haiti, and the Bassett family made many friends among the people.

This would have been difficult enough in peacetime, but Bassett had gone from one civil war to another. Revolution, coups d'état and chaos were commonplace during his years on the island. After all, the former ambassador had actually been wounded in the head with a hatchet. He told Frederick Douglass that his job was "delicate" and he would need "common sense" and "some little knowledge of law." He also prudently leased a fireproof building. He wrote of the frequent "arbitrary arrests and unwarranted infringements" that he sometimes had to intervene to stop, when they involved Americans, as they often did. Some of these were justified, but others were not, and on more than one occasion he stood up to the Haitian government, invoking diplomatic immunity and successfully taking the parties to arbitration. His determination and humanity saved many individual lives during these difficult times, and he prevented several wars between the two countries, wars that would surely have ended this "black republic" of the Caribbean through annexation. Indeed, many in the American government urged for such a result, and Bassett had to be a true diplomat and work always toward peace.

For almost nine years, he dealt with various administrations, rebels and favor-seekers with grace and aplomb. But the crisis with General Pierre Boisrond Canal was his most difficult challenge. President Domingue had put this political rival on a list, and one night, Canal knocked on Bassett's door, asking for asylum. The American had never met the general before but agreed to protect him and his relatives, saying, "The instinct for humanity got the better of me." A thousand armed men "with discontent stamped on

their faces and Henry rifles in their hands" surrounded his house, screaming and banging metal together.

The siege dragged on for weeks, but while Domingue's supporters remained outraged, the popular opinion of the rest of the Haitian people began to shift, and he and Canal earned folk hero status during what he called a "reign of terror." Finally, the navy agreed to send a man-of-war to the Port-au-Prince Harbor, and the threat caused Domingue to back off. General Canal boarded an American ship to Jamaica, thanking Bassett, who had put his job and credibility on the line for men he did not even know.

However, as usually happens with diplomats, a change of president meant that soon enough he was out of a job. Secretary of State F.W. Seward expressed his appreciation for Bassett's work, mentioning that "at various times your duties have been of such a delicate nature as to have required the exercise of much tact and discretion." This was perhaps an understatement. He was only forty-four years old and in need of new work. The family returned to New Haven; his daughter Charlotte became a teacher like her father, and little Ulysses attended the prestigious Hopkins Grammar School.

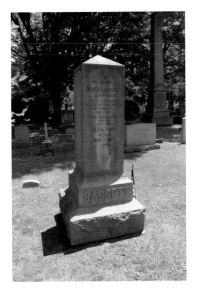

Ebenezer Bassett is buried in New Haven's Grove Street Cemetery, along with other Connecticut luminaries like Eli Whitney, Charles Goodyear and Noah Webster. *Courtesy of the author.*

Bassett himself was in demand as a public speaker, though it wasn't exactly high-paying work.

The man he had saved, Canal, had become president, but constant infighting drove him from his country in disgust. However, in 1879, the next president of Haiti offered Bassett a job as consul in New York. It was the perfect occupation because his family could stay in New Haven while he commuted into the city. When his friend Ulysses Grant died, he took part in the massive funeral procession, leading the diplomatic corps just behind former presidents Hayes and Arthur as the procession slowly made its way north through Manhattan.

In 1888, his friend Frederick Douglass was appointed as the new ambassador to Haiti, and Bassett took the post of his secretary, helping the aging Douglass as much as he could. During one of the

endless revolutions, Douglass became trapped at a café in Port-au-Prince. The younger Bassett rushed him to safety. Soon afterward, the infirm Douglass left Haiti and was forced to resign. No one dared to attack the legendary Douglass in the newspapers, so they turned on Bassett instead, telling the usual lies about his unfitness for the role. Douglass defended him, but in such a way that neither man would ever get a posting from that administration.

In 1895, both Douglass and Eliza passed away, leaving Bassett bereft of best friend and wife all at once. He watched helplessly as the Jim Crow laws reversed much of the progress that had been made after the Civil War. The American government certainly wasn't going to give a black man such a high-ranking position again anytime soon. So, when in 1898 the Haitian government asked for his help during the Spanish-American War, he served as their vice consul general for ten years until his death in 1908.

Pioneers don't often get to see the results of their work, and Ebenezer Bassett must have felt frustrated near the end of his life. But as Martin Luther King would say a half century later, quoting abolitionist Theodore Parker, "The arc of the moral universe is long, but it bends toward justice." As our first black diplomat, Bassett had bent that arc, just a little bit, and had shown another face of America to the world.

Chapter 12

JOHN PIERPONT MORGAN

MASTER FINANCIER

From his front porch on Asylum Street, John Pierpont Morgan could hear the train whistles of the Hartford and New Haven Railroad, which had just started operation a few years earlier. With hazel eyes and brown hair, the good-looking boy always seemed to be serious to adults he met. However, his father was never satisfied with John's educational progress, shuffling him around from school to school. In the fall of 1848, he attended Hartford Public High School but three years later transferred again, down the turnpike to Cheshire's Episcopal Academy. While there, he studied mathematics and Latin and, in his free time, fished, sailed and worked in the garden. And he could hear the train whistle in Cheshire, too. It was the sound of the future.

As a teenager, he worked in his father's store, learned to hate slavery and began to explore the worlds of business and banking. He had a leg up; after all, his grandfather was rich, with almost $1 million in the bank at his death. At age fifteen, he suffered rheumatic fever and, as only the son of a rich family can do, recovered in the Azores for a year. When he came of age, he moved to New York City at the same time fellow Connecticut original Frederick Law Olmsted was designing Central Park. But Morgan had other designs; railroad securities became popular in the 1850s, and he began buying shares.

He met the bright and intelligent Amelia Sturges, who he called "Memie," and fell in love. But after an all-too-brief marriage, she died of consumption and was buried in Fairfield. After a period of mourning, he met Frances

Louisa Tracy at church and began a new courtship, and this time it yielded a long marriage and four children. At first, he lived on Madison Avenue but soon moved to a big house on Fourteenth Street, "far more downtown than I like." He continued working his way through Wall Street, learning the ropes of finance and trade, keeping his eyes on the bottom line and on the future.

In the 1860s, the various railroads were in competition, with different gauge tracks and different owners. If you arrived at the end of one company's line, you had to disembark and get on a new train, because cars had to stay on their own tracks. Some had actually tried to cooperate but failed. Needless to say, this was an untenable situation. One solution was to nationalize and regulate the railroads, but in a country as vast as America, it would have been a challenge. Besides, the federal government at the time was weak and unable to act on such a large scale.

By the 1870s, Andrew Carnegie was consolidating the steel industry and John D. Rockefeller was consolidating oil. With more capital and connections than his grandfather could have dreamed of, Morgan decided to unite the numerous railroads. He was not nearly as rich as Carnegie or Rockefeller, though few knew that fact until after his death. But what he could do was mobilize other people's capital. He understood the way that Wall Street worked better than anyone and found partners willing to help. Through new methods of corporate finance and industrial consolidation, he standardized the railroads and made train travel easier. He also took over companies and reorganized them to be profitable, providing a model for this type of corporate takeover, called "Morganization."

By now, Morgan had grown a huge walrus mustache, in part to hide the rosacea marring his face. His nose, too, was pitted and deformed by rhinophyma, and he stopped letting people take photos of him. Despite or perhaps because of this, his tremendous physical presence could intimidate anyone, as he swept into rooms like a hurricane and bent everyone to his will. Of course, those who knew him saw a different side: a shy and untalkative man who loved art and smoking his large Havana cigars. He put "character" ahead of everything; if you didn't have it, he would not lend you money.

In 1879, he and his group ran a "refunding" operation, which cut off the Morgan family's dependence on the European Rothschilds and signaled a shift of power to the Western Hemisphere. He began moving wealth from Europe to America, wealth that was used to build infrastructure and industry. Along with gold, he brought great European art into America, including paintings, relics, antiquities, furniture and manuscripts. He spent millions on this and donated most of it to museums.

Called the Gilded Age by Connecticut's own Mark Twain and Charles Dudley Warner, the late nineteenth century was a time of growth; population, industry and wealth all boomed throughout the country. However, there were serious problems with this new boom-and-bust economy. Without anyone to stabilize it from time to time, numerous "panics" ripped through the country, causing the loss of personal fortunes among the wealthy and the loss of livelihood among the working classes. In 1893, one of these panics caused a recession, and two years later, the government was about to default on its loans. Morgan saved the federal treasury by teaming up with a banking syndicate to sell bonds and buy back gold from foreign investors. He received the thanks of President Grover Cleveland and stopped the entire nation from going bankrupt.

Companies continued to grow bigger and bigger, and the consolidation that had seemed so natural in the 1870s now seemed to be getting out of hand. In 1892, Morgan helped Thomas Edison form General Electric and later financed the creation of International Harvester and AT&T. In 1901, he facilitated the merger of Andrew Carnegie's steel company and other companies into U.S. Steel, creating the first billion-dollar company in the world and signaling America's preeminence as an industrial power. However, these "monopolies" and "trusts" often crushed free enterprise and

This cartoon of J.P. Morgan "helping out" Uncle Sam was meant as satire but in some ways showed their true relationship. *Library of Congress.*

small business, exerting too much control over labor and capital alike. Men like President Theodore Roosevelt argued against them, and as president, he even brought suit against one of Morgan's companies. When Morgan went to the White House to complain, Roosevelt said that he would not compromise, and the courts would decide the matter.

In 1901, when a group of rivals attempted to buy one of Morgan's railroads, he stopped the coup, only to find that their combined actions had precipitated a panic in the markets. He sold shares at a low price to calm investors in both New York and London. During the Panic of 1907, the New York banks were about to collapse, as they seemed to do every decade or so. Morgan worked with a few partners, and by selling and buying stocks, they saved the country from a depression. He may have been self-interested in both of those cases, but he saw his own interest and America's interest as intertwined and even interchangeable.

At age seventy-five, he was brought before the Congressional Banking and Currency Subcommittee, which was suspicious of so much power in one man's hands. This inquiry would lead to the formation of the National Monetary Commission and later the Federal Reserve. After a congressional interrogation, he traveled to Egypt and Rome, dying in his sleep there among the antiquities he loved. His body was brought back to Hartford and buried in Cedar Hill Cemetery, alongside many other Connecticut luminaries.

In truth, Morgan was probably neither the secretive predator described by his enemies nor the generous priest of capitalism described by his hagiographers. He was just a man, but one who revolutionized the way business was done in America, combining financing and banking with industry and trade in a way and on a scale few had before.

Chapter 13

ALICE HAMILTON

FARSIGHTED SCIENTIST

I n October 1886, seventeen-year-old Alice Hamilton arrived at Miss Porter's School for Young Ladies in Farmington, Connecticut. Originally from Fort Wayne, Indiana, she joined her older sister Edith and made friends with a rich girl from New York named Katharine Ludington. All three would excel at this groundbreaking school with no grades or exams and go on to be part of the first generation of college-educated women in the country, a generation that would transform the cultural and social landscape of America.

Though young Alice spoke of her crush on a handsome neighbor, she knew even as a teen that most boys were not smart enough for her. Besides, like many educated women in the late nineteenth century, she believed that she would have to choose between familial happiness and education. She consciously chose education, aspiring to be a doctor, a profession, as she said, "of use anywhere." It was actually a growing field for women; at the time, there were 4,500 female doctors in the States. However, when Alice told Miss Porter she wanted to be a doctor, the famous educator was not exactly encouraging, treating it as "amusing childish whim."

She ignored this advice and after two years of hard work graduated from the University of Michigan Medical School in 1893, continuing her education with internships in Minneapolis and Roxbury, Massachusetts, which reminded her of Farmington. "In the distance, the Blue Hills looking very like our Farmington hills," she said fondly. At first nervous about working in a hospital laboratory, she soon took to it wholeheartedly,

pushing through strict Victorian social conventions when medical necessities required. She was always busy but found time to write letters to her sister on prescription pads. "The work is fine," she said, "but it is a pretty lonely, desolate sort of life."

She decided against medical practice, turning instead to research. "I must do scientific work," she said firmly at the time. She tried her hand at bacteriology, taking classes first in Michigan and then in Germany near her sister Edith, who was studying the classics. However, she found the local cultural attitudes "hypocritical" and her own proclivity for bacteriology less than she had hoped. She tried postgraduate studies in pathology at Johns Hopkins next. But something was missing, some vision aching in the back of her mind. She could not quite see it yet.

In 1897, she took a job as professor of pathology at Northwestern University's Woman's Medical School. She became a member and resident at Chicago's Hull House, founded by Jane Addams and Ellen Gates Starr as a social experiment. She became Jane Addams's doctor and taught classes at the house, including English, art and men's fencing. She also ran the baby clinic and worked as a visiting physician. But she was not satisfied, speaking of "a series of failures to look back on and not only individual failures but one great fundamental one." The great fundamental failure in her mind was being thirty years old and not yet finding her calling.

She kept studying instead, earning another degree in neurology and studying the brains of rats and humans. During a typhoid epidemic that same year, she ascertained that sewage and poor plumbing was at fault by capturing flies, testing them and presenting her findings to the *Journal of the American Medical Association*. After this success, she studied the negative effects of cocaine and also worked on the eradication of tuberculosis. However, there were many people working in this field at the time. What particular good could she do?

During her medical work with the poorer residents of Chicago, she began to notice the health problems caused by factory work. Then in 1907, she read the European data on industrial medicine and realized how far behind America was in ensuring that workers did not have to "sacrifice life and health." She wrote articles and conducted studies on industrial poisons like phosphorous and lead. A year later, she was appointed to the brand-new Illinois Commission on Occupational Diseases, and by 1910, she was a medical investigator. She had found her vocation, one that blended her broad medical knowledge and her seemingly limitless compassion.

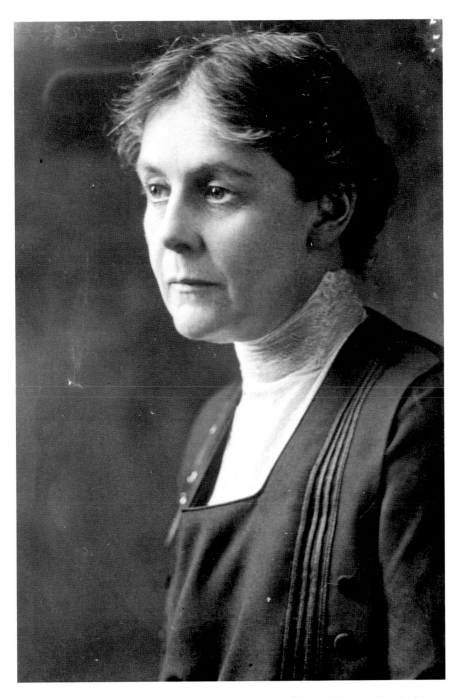

When Alice Hamilton became the first female professor at Harvard, she was already the foremost expert in the world on industrial medicine. *Bain News Service, Library of Congress.*

Much of this practice involved "shoe-leather epidemiology," investigating death records, interviewing workers and their families. And she definitely met with her share of sexist attitudes—after all, wearing worker's overalls and sleeping in mining shacks was not a woman's place. She was not a big woman; some called her "fragile" in appearance. Still, this "femininity" may sometimes have helped her, since the factory workers accepted her compassion, and her detective work, more easily. Years later, when presenting Hamilton with an award, Eleanor Roosevelt said, "When she said that in her field she had encountered very little opposition, your instinctive reaction was that no one could help wanting to be of service to her."

She was certainly successful in her early investigations, establishing "without a doubt" problematic uses of lead in many Illinois industries. "I go to the factories," she said. "And I see conditions which make for lead poisoning and then it is the most desperate work finding any." This was not because lead was not present but because everyone denied their health issues. People were suffering and dying, but to admit illness was to lose their jobs. She kept meticulous records, which did not stop her from being attacked by companies and their doctors, but it did make it difficult to refute her claims. And she was not just finding obstacles; she was offering solutions to these factories, explaining how various safety methods would alleviate the problems.

By 1915, she was one of just a few experts in the country on industrial diseases but remained a nomad without a true home. She often visited her old friend Katharine Ludington, now a suffragist and social reformer living in her father's former mansion in Old Lyme. Alice fell in love with the area around the mouth of the Connecticut River so much that she decided to settle there. Katharine found her a nineteenth-century Federal-style house in Hadlyme, just by the Chester ferry. "Hadlyme is really my child," she said, proud of her house and its "charms and delights." She would live there for the next fifty-five years.

In 1919, Harvard offered her a job as assistant professor of industrial medicine, and she became the first female professor there in any field. Headlines across the country read "The Last Citadel Has Fallen" and spoke of her breaking down the gender barrier. "I am not the first woman who *ought* to have been called to Harvard," she commented wryly. She was still banned from marching in commencement or receiving her faculty tickets to football games. Nevertheless, she gave the Cutter Lecture on Preventative Medicine and Hygiene, became the associate editor of *Journal of Industrial Hygiene* and wrote the groundbreaking book *Industrial Poisons*

in the United States. Like fellow original Frederick Law Olmsted, she had created her own field.

But pure scientific work or even teaching was not enough. She believed that science could and should be part of public policy, and together they could save lives. She had no axe to grind with industry itself, saving her scorn for hired doctors who didn't do their duty, putting company owners' interests over their Hippocratic Oaths. Sometimes, speaking to manufacturers was enough, convincing them to do the right thing without threatening lawsuits or exposure in the newspapers. However, she couldn't be everywhere, and many owners refused to institute humane regulations.

In 1920, her cousins bought a house only a few miles away in Deep River, bringing her family close. However, she was often on the road, traveling from Hadlyme to Boston each autumn and continuing to visit Jane Addams in Chicago. She was also offered a job with General Electric but found little to do because their facilities were "tame" compared to the ones she was used to inspecting. In 1924, she was appointed to the Health Commission of the League of Nations. As a speaker and consultant all over the world, she had enough on her plate. However, she continued her work investigating benzene in the rubber and canning industries. She found it to be so dangerous that "only a small quantity" was required "to poison or even to kill."

During those decades, she supported radical ideas like women's suffrage, peace and birth control. But that did not stop conservative President Herbert Hoover from appointing her to the Research Committee on Social Justice. In 1934, her second book, *Industrial Toxicology*, was published, cementing her place as the preeminent authority in the field. Meanwhile, her home became a gathering place for her extended family and friends like Jane Addams, whose last days were spent by Hamilton's side. Unfortunately, that same year, 1935, Harvard insisted on a more uniform retirement policy, and though she had no wish to stop teaching, at sixty-six years old, she was forced to. Harvard did not know that despite exposure to industrial chemicals her health remained fantastic and she still had another thirty-five years to live.

She did not stop working, studying the dangers of paint silicosis and rayon manufacturing. In 1942, she wrote a memoir called *Exploring the Dangerous Trades.* Finally, the general public could appreciate and understand the work she had done. In 1947, she was given the Lasker Award for her contributions to workers' health. Two years later, at age eighty, she remained a consultant for the Department of Labor and revised *Industrial Toxicology.*

In her eighties, she finally slowed down her public work, resigning a few of her many positions, such as president of the National Consumers League.

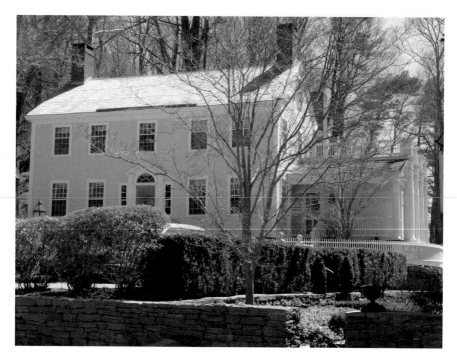

This house by the ferry in East Haddam provided Alice Hamilton a needed respite from traveling the world and saving lives. *Photograph by Lee Edwards.*

She worked at her Hadlyme house in the morning on letters, books and lectures before cooking a large lunch. In the afternoon, she gardened, she stretched wearing jeans and sneakers and walked through the beautiful Connecticut countryside. In the evening, she entertained guests, and at eleven o'clock promptly, she went up to her third-floor bedroom. At eighty-eight, she said, "Life is still as interesting as ever. I should hate to leave, for I do not know what will happen next."

At 90, her colleagues established the Alice Hamilton Fund for Occupational Medicine at Harvard, though the university itself wouldn't give her an honorary degree. Nearby Yale University recognized her accomplishments with a degree instead. Her sister Edith was also honored for her many contributions to classical culture by King Paul of Greece, who gave her his country's highest honor, the Golden Cross of the Order of Benefaction. The two women had come a long way from Miss Porter's School and could enjoy their laurels together before Edith died a few years later. She was interred a few yards from the Hadlyme house, and though Alice herself kept strong through most of her 90s, her own movements

were limited by a series of strokes. Luckily, her room had views of the Connecticut River, and she often watched the ferry come across from Chester while waiting for the other ferry, the one that her sister Edith wrote about in her books of Greek mythology. It finally came for her in 1970, when she was 101 years old.

Three months after she died, the Occupational Health and Safety Act finally authorized the government to enforce healthier environments for all American workers. Hamilton's pioneering work in industrial toxicology showed that although science could sometimes create health problems, it could also identify them and suggest solutions. And with an active public policy, those solutions have had an impact on the lives of millions.

Chapter 14

CHARLES IVES

UNCOMMON COMPOSER

During the Civil War, George Ives had been the youngest bandleader in the Union army, and he was now a conductor in a town of hatmakers. When his son Charles was born in 1874, he introduced him to music, and by age five, Charles was pounding away on the piano as if it were a drum. Among other investigations, the "oddball" experimenter George would march two bands around the Danbury parks in opposite directions. The musicians would play different tunes, and Ives and his son would listen to how the discordant music changed when they passed each other. At home, George would play in one key while Charles sang in another. Once, when they were listening to a stonemason sing passionately, off-key, George told his son, "That's the real thing, the music of the ages." It was a lesson that young Charles took to heart, and the music he would create was full of the discord and sentimentality of "real" music.

By thirteen, Charles was composing marches and hymns, and by fourteen, he was getting paid to play the organ at the local church. Like any other adolescent, he was "partially ashamed" that he wasn't out "playing ball," but he stuck with it, resigned to being "the other oddball in the family." Ives's first compositions were performed at Elmwood Park's bandstand—appetizers for the musical feast to come. By seventeen, he had written variations on "America," which is still played by organists around the country. He was already studying polytonality and composing tunes with counterpoint, whimsical tunes that blended marches, hymns and classical music. He used musical collage and spatial music long before terms for them were coined.

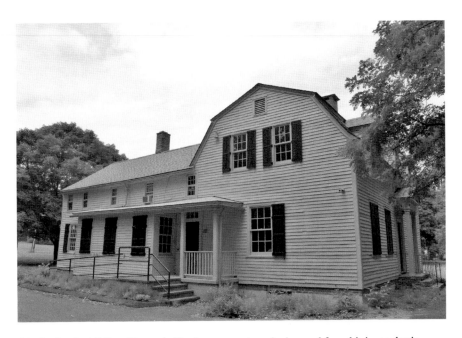

Charles Ives's childhood home in Danbury was where he learned from his iconoclastic father to think differently about music. *Courtesy of the author.*

In 1893, Ives traveled across the state to Hopkins Grammar School and prepared himself to enter Yale. Weak in other subjects, he barely made it in and did not excel once there. But he had the chance to study under Horatio Parker, probably the best teacher of musical composition in the country. Parker taught him music history and symphonic structure, giving him an academic and formal refinement his father could not. And just then, George Ives died of a stroke, a loss that touched Charles deeply and prompted him to keep the memory of his father's madcap improvisation and atonality alive, combining them with the deep structures of European classical music and creating some of the most original sounds of all time.

Ives continued to play music as well as compose, acting as organist for New Haven's Center Church, sitting in for accompanists at theaters and pounding out ragtime tunes at fraternity parties. He and Horatio Parker argued in a friendly way about how many keys a song could go through. However, on graduation, he did not become a professional musician or teacher and instead took a job as a clerk for the Mutual Life Insurance Company. "How can he [a musician] let [his family] starve on his dissonances?" he wrote.

He moved to New York, working as an organist and choirmaster but making his actual money in life insurance. He composed new works but

nothing that would be called strange or radical. But as the new century dawned, his compositions became original to the point where no one at that time would or even could perform them. He began to blend traditional classical genres with folk music, ragtime and gospel in ways that his contemporaries could not handle. He actually "quit music," resigning any formal position, but continued to compose experimental works like "Central Park in the Dark," "Scherzo: Over the Pavements" and what many consider his masterpiece, "The Unanswered Question." It was a challenge to listeners and most of all to other musicians; no one would catch up to its use of silence and sonic texture for another fifty years.

Meanwhile, he and his friend Julian Myrick founded what would become the largest life insurance company in America. And if that wasn't enough to keep Ives busy, he suffered a heart attack and depression and wooed a woman named, appropriately, Harmony. She was the daughter of Mark Twain's good friend Reverend Joseph Twichell of Hartford and sister of one of his Yale friends. He had spent a few summer vacations with the Twichells, and in 1905, they fell in love and began a correspondence. She brought a spiritual element into Ives's life and his music when they married in 1908, telling him, "The flame of love…is the most purifying and illuminating thing in this world." They honeymooned in Salisbury, Connecticut, climbing Mount Riga and traveling up and down the river. On a Sunday morning walk with Harmony a month later in Massachusetts, Charles was inspired to write "The Housatonic at Stockbridge," the last movement of his great twenty-minute piece *Three Places in New England*.

"Housatonic" is a great example of Ives's use of unconventional musical devices, beginning with his conception of a dialogue between instruments, rather than synthesis. It is a "slow" movement but makes the listener vaguely uncomfortable, creating a tension that is finally released when the conversation reaches a sort of spiritual, "sunset" conclusion. The incredible dissonance and irregular texture of the piece must have been jarring to his contemporaries, though slightly less so to those of us who know the jazz of Charles Mingus or experiments of John Cage. The whole of *Three Places* uses simultaneous melodies, quoting from hymns and marches, building huge groups of sound, tone clusters that you might have heard in Jelly Roll Morton's ragtime rather than in "classical" music.

His new happiness with Harmony led him not only to succeed in the life insurance game but also to compose at an incredible pace: symphonies, sonatas, overtures and quartets that reach for the celestial while maintaining their human details. It was music for musicians, to play, to listen to, to wonder

Even as a young man, Charles Ives showed incredible promise as a musician and composer. *By E. Starr Sanford, via Wikimedia Commons.*

at. "Music is life," he said with confidence. It may have been his life, but it was not selling well. Between 1902 and 1920, Ives had no public performances of his work and separated himself from the musical establishment in an unprecedented way. Of course, those he did show it to often expressed laughter and outrage at what they felt was "crazy" music or not music at all. "I felt," he said in a fit of self-doubt, "that perhaps there must be something wrong with me. Said I to myself, 'I'm the only one, with the exception of Mrs. Ives, who likes any of my music, except perhaps some of the older and

more or less conventional things. Why do I like to work in this way and get all set up by it, while…it just makes everybody else mad?" But in 1914, when his partner Myrick almost threw out a draft of "Fourth of July," Ives cried out, "Why Mike! My God! That's the best thing I've written!"

Harmony brought him again and again out of rage and despair, encouraging him to continue his "oddball" music and giving him the time to compose his songs and symphonies. He focused on his business, adopted a child in 1917 and campaigned for war bonds during World War I. He wrote a book called *Life Insurance with Relation to Inheritance Tax*, and his readers and peers were always surprised to find out that he was "also" a composer. That same year, he had another heart attack. Afterward, he did not slow down as he should have and kept composing furiously, finding an apprentice in the young Henry Cowell and a few "ultra-modernist" venues that would play his work. But his health continued to fail, with diabetes adding to his troubles. In 1927, he found he couldn't work anymore, telling Harmony, "I try and try nothing comes out right." By 1930, he had resigned from his own insurance company and remained essentially convalescent for the rest of his life. All who met him found him funny and optimistic, though, and he was able to tinker here and there with his *Fourth Symphony*, though it remained fragmentary.

However, other musicians began to hear his work, and play it, including Aaron Copland, whose own "American" style owes much to Ives. In 1939, his "Concord Sonata" with its musical portraits of Emerson, Hawthorne, Thoreau and the Alcotts was performed in New York, and other musicians sat up and noticed. One critic said, "It is informed with the stark and ascetic beauty of lonely and alien reaches of human imagination." By the 1940s, he had won a Pulitzer, and *Life* magazine was knocking on his door. A young Leonard Bernstein became a huge fan, calling Ives "the Washington, Lincoln, and Jefferson of music." When Bernstein conducted the world premiere of Ives's *Second Symphony* in 1951, Harmony sat in the audience and listened in amazement at the shouts and applause. "Why they *like* it, don't they?" she said in wonder. Suddenly, the world was catching up with the Danbury composer, and oddballs finally seemed to rule the day.

Charles and Harmony remained happy and devoted, staying as close as they promised when she shared her hope that she would "keep my heart and life what our love would have it." He passed away in 1954, a decade before his reputation achieved the levels he deserved, donating the proceeds from future royalties to the American Academy of Arts and Letters, to be given as a prize for young composers. However, before he died he at least seemed

confident in the worth of his own music, with its democratic flavors and discordant notes of the modern world. Even his grave in Danbury was full of hope and faith, reading: "Awake psaltery and harp: I myself will awake right early."

It is a fitting epitaph for one of the most radical composers of all time. His music may still provoke laughter or confusion, but it will certainly not put you to sleep.

Chapter 15

HELEN KELLER

EXTRAORDINARY ADVOCATE

O n a cold winter day in 1901, Helen Keller had dinner in Ridgefield, Connecticut, with Mark Twain. He had met her before, and as a child, Helen had appeared, in Twain's words, "a lump of clay… deaf, dumb, blind, inert, dull, groping, almost unsentient." Through Anne Sullivan's remarkable teaching, she had been made more than someone "governed only by animal impulses," as Helen herself put it later. Instead, she was able to access what Twain described as the "fine mind" and "bright wit" she had been born with and transformed into "a wonderful creature who sees without eyes, hears without ears, and speaks with dumb lips." Now they enjoyed dinner together, the aging author and the young woman, while Sullivan translated, spelling each word out into Keller's hand. Twain was amazed, saying he was "not quick enough to follow their movements." He made his usual jokes, and she talked "back as good as she gets…with subtle pathos and charm." He read stories out loud, and she touched his lips, following them through their movements. In turn, he watched "the moving and eloquent play of emotion in her face."

The year before, Twain had dug up the money for Helen to attend Radcliffe, where she rocketed into new realms of thought, taking Descartes' maxim, "I think therefore I am," and holding onto it for the rest of her life. If she could think, she was a full human being, something that may seem obvious to us today but was not to some of her contemporaries or even her classmates. To many of them, she was also a distant celebrity and experienced "a depressing sense of isolation." She

managed to have fun anyway and may have begun her lifelong taste for a nice glass of Scotch whiskey.

In 1903, while she was still in college, her first book, *The Story of My Life*, was published, telling the tale of her childhood in Alabama. The tale of being struck deaf, dumb and blind from an illness before the age of two was already fairly well known throughout the country, but to have it from her own pen was a novelty, and the book became a bestseller. Many, however, accused her of not writing it at all and posited that her editor, Anne Sullivan's husband, John Macy, had written the whole thing. She ignored this criticism and continued to write for magazines and compose new books like *The World I Live In*, a startling attempt to explain to readers what it was like to be deaf and blind. She begins one chapter:

> *I have just touched my dog. He was rolling on the grass, with pleasure in every muscle and limb. I wanted to catch a picture of him in my fingers, and I touched him as lightly as I would cobwebs; but lo, his fat body revolved, stiffened and solidified into an upright position, and his tongue gave my hand a lick! He pressed close to me, as if he were fain to crowd himself into my hand. He loved it with his tail, with his paw, with his tongue. If he could speak, I believe he would say with me that paradise is attained by touch; for in touch is all love and intelligence.*

In 1913, her more political book *Out of the Dark* was a failure, and she was criticized for being a "socialist." Many did not believe she *could* form opinions about politics, and the newspapers were often critical of her "handlers," who they claimed were "using" Keller to get across their own "radical" opinions. But what Anne Sullivan had truly taught her was to see herself and other disabled people "not as a class apart but as human beings endowed with rights." Her opinions often angered people, but she kept voicing them. After all, few wanted to get in a public fight with a deaf and blind person, particularly one as popular as she was. She fearlessly wrote *My Religion* in 1927, saying, "To one who is deaf and blind, the spiritual world offers no difficulty."

Her argument was that she was not only a sightless person who could speak on behalf of the sightless but a full citizen who could speak on whatever she liked. Of course, she was most successful when she acted as an advocate for the disabled, in 1915 founding the Helen Keller International and in 1920 helping to found the American Civil Liberties Union. A year later, she helped found the American Foundation for the Blind (AFB),

for which President Calvin Coolidge served as honorary chairman. With her celebrity, this foundation became the leading voice for the blind in the country. However, her politics and those of the wealthy donors often clashed, and she often felt she had to "stay silent" when she acted on the AFB's behalf. Nevertheless, she was likely the best fundraiser and lobbyist for disabled people ever to live.

They needed her voice more than ever during those years. Her life and her works were a direct rebuke to the eugenics movement popular throughout the world at the time. When her books were burned in Germany, she knew what the Nazi ideology would eventually mean for people with disabilities. Her fears were realized a few years later when many of these "unfit" people were sent to the gas chambers.

The woman she called Teacher, Anne Sullivan Macy, deteriorated in the 1920s while they lived together in Forest Hills, New York, dying in 1936. That same year, Keller chose the "sleepy town" of Easton, Connecticut, as her home, naming the black-shingled white "farm-house" Arcan Ridge. Her helpers included Polly Thompson and later Winifred Corbaly and Evelyn Seide, who assisted her with housework and other daily activities. She took daily walks along the thousand-foot handrail into the gardens and woods. She also loved to go to the nearby hot dog stand and always asked for mustard. Through her social network in nearby Westport, she met with prison reformers, economists and even Countess Alexandra Tolstoy. Neighbors stopped by, like literary historian Van Wyck Brooks, with whom she discussed Thoreau. She participated vigorously in every discussion, surprising those meeting this outspoken woman for the first time. Her "intellectual hunger," as she called it, was never satisfied.

Soon after moving to Connecticut, she traveled to Imperial Japan, trying to convince the Japanese "that their handicapped can, if given a chance, become useful and reasonably happy human beings." She also visited Korea and Manchuria, against the advice and wishes of the United States government. While she was there, Japan invaded China, and she could not continue the trip. Soon enough, the war spread, and back home in the United States she helped to develop "protective measures" for the blind and deaf during air raids. She visited disabled veterans in navy hospitals, giving her usual blend of positive attitude and practical advice. She also publicly supported efforts to get the disabled work, believing it was the best method of rehabilitation.

In 1946, she toured the battle-scarred countries of Europe, both Allied and Axis. While she was there, her house on Arcan Ridge burned

Mark Twain called Anne Sullivan the "miracle worker" for allowing Helen Keller to live a normal life. Instead, she lived an extraordinary one. *Library of Congress.*

down, and though it was rebuilt, the fire took her correspondence and notes for a book about her beloved mentor Anne Sullivan. She had also become disillusioned by the infighting between the various foundations, associations and societies formed to help the disabled. Perhaps in part as a reaction to these setbacks, perhaps as a natural evolution of her compassionate nature, in the late 1940s, she expanded her advocacy to all people, particularly, as she put it, those with "fettered minds and imprisoned lives." She gathered strength at her little house in Easton, sending letters to world leaders, planning goodwill trips and rewriting the lost book *Teacher*. This quiet, shady spot in Connecticut might seem a strange place to wage a campaign as an ambassador of humanity, but over the centuries, many in the vanguard have found the opposite to be true.

Because her advocacy was for all human beings, her politics clashed with nearly all governments at one point or another. For example, in 1948 she flew to Japan, while it was still occupied with American troops, publicly supporting the introduction of democracy. But experiencing the aftermath of Nagasaki "scorched a deep scar in my soul" as she "stumbled over ground cluttered in every direction" and "smelt the dust from the burning." In an unpopular opinion for an American, she lamented the use of the atomic bombs, long before others came to that conclusion. It seemed as if she could please no one, but at the same time, her popularity remained persistent with people all over the world. She visited the newly formed Israel but also Syria and Jordan. In 1951, she visited South Africa and met with Zulu people, visiting twenty-eight schools and lecturing to forty-eight groups. She opposed apartheid publicly and became equally frustrated with racism and indifference, fighting, as she said, "against an impenetrable wall."

Through the 1950s, she continued to write and travel the world, visiting schools for blind children and prime ministers alike in India and the Philippines, Sweden and the Netherlands. She always enjoyed talking to people but grew uncomfortable with her public image of "sainthood." In Norway, she was given a parade, and she and her companion Polly "felt like a pair of bloody fools." And though to many she was an example of "self-reliance" and the American dream, she hated that her own example could be used as an excuse not to protect or help the disabled or the oppressed.

Often, her visits were supplemented by public presentations of the documentary *The Unconquered*, which portrays her as an energetic and compassionate figure but whitewashes her progressive politics and gives her a halo of near sainthood. The 1962 film *The Miracle Worker* brought her

When she was not traveling the world advocating for the disabled, Helen Keller lived and wrote for more than thirty years in the woods and gardens of Easton, Connecticut. *Library of Congress.*

story to even more people, its title taken from Mark Twain's description of Anne Sullivan half a century earlier. Its portrayal of the symbolic baptism at the water pump continued her legendary status as a sort of twentieth-century saint.

By that time, she could barely summon the energy to protest. In 1961, she suffered a stroke and spent her last years in Easton, surfacing briefly

to accept the Presidential Medal of Freedom from Lyndon Johnson. She passed away at her beloved home of Arcan Ridge in 1968, a few weeks shy of her eighty-eighth birthday.

Mark Twain said of Keller as early as 1901, "She stands alone in history." It is certainly extraordinary that a woman who could not hear or see was able to convince everyone she met that she deserved the full rights of any human being—more so at a time when such rights were often called into question. But what is most extraordinary is that she spent her life making sure that she was not the only one who had those opportunities.

Chapter 16

EUGENE O'NEILL

PASSIONATE PLAYWRIGHT

T he theater is dying," James O'Neill told his son Eugene, one of the first things he would remember his father saying. Later, Eugene understood this as a curse his father felt, the curse of melodrama that he had been pigeonholed into by the success of his role as the Count of Monte Cristo. He determined that unlike his father, he would never "sell out," and he determined to exorcise the curse of melodrama from the American stage.

In 1885, the O'Neill family settled in "Monte Cristo Cottage" in New London, halfway between the theaters of New York and Boston. His mother, Ella, had lost her son Edmund and had taken more and more to the solace of morphine. Then, after a series of false starts, Eugene was conceived and born on October 16, 1888. He had nightmares throughout his childhood, as well as cases of colic, rickets and typhoid fever. James would apparently give the boy whiskey to soothe him. Ella continued to take morphine, confusing her son with her odd behavior. Rather than loving her, he came to see her as a "character," a "type," someone to be studied and pitied.

He was a lonely child. Going on tour with his parents or left briefly at different boarding schools, he rarely made friends with other children. And yet his parents, James and Ella, could not communicate with each other and certainly didn't know how to talk to him or his older brother. In 1900, they bought a larger house a few doors down on Pequot Avenue, naming the second Monte Cristo as well. Eugene's bedroom window looked out onto the foggy harbor and across to the huge obelisk of the Groton Heights

Monument. He could hear the sad cries of the lighthouse at the end of the avenue guiding ships in through the fog along the wide Thames estuary.

The turn of the century saw a few changes in acting, with fellow Connecticut actor and playwright William Gillette adopting a more naturalistic, subtle style and adding other things like more realistic light and sound effects. But the plays themselves were still melodramatic rather than dramatic, with plot twists, mustache-twirling villains and damsels in distress. Every autumn, the O'Neill family would leave the house to travel one of James's endless tours as the Count, and occasionally Eugene would be sent to Catholic boarding school. But at the precocious age of fourteen, he renounced Catholicism and was sent to Betts Academy in Stamford instead. By 1902, he looked like a man, tall and thin, with deep, dark eyes and rich black hair. Unfortunately, he had adopted the family habit of drinking and had already experienced his first blackouts.

He failed out of Princeton University, impregnated a girl and secretly married her, sailing away from his new wife as a working passenger on a commercial sailing vessel, ending up in Buenos Aires. He began watching European plays like *Hedda Gabler* and *The Playboy of the Western World* and became inspired to write a new type of American play. However, his life remained unhappy; in January 1912, he may have attempted suicide, something that is alluded to in his plays and letters. His mother had done the same years earlier, and he could sense that he was repeating these family patterns but couldn't seem to escape them.

"There is always one dream left," O'Neill said once. "No matter how low you have fallen, down there at the bottom of the bottle." He returned to New London, got a job at a local newspaper and fell in love with his grocer's daughter. His father bought a nearby farm, which later became the setting for Eugene's play *A Moon for the Misbegotten*. And then, suddenly, he began to cough. At first diagnosed with pleurisy, he actually had the deadly disease tuberculosis. Though a mild case, he needed to get help, and after a short time at a state facility in Shelton, he was soon sent to some of the best doctors in the country at Gaylord Farm Sanatorium in Wallingford.

Set on almost three hundred acres of rolling farm and orchards, the grounds had a view to the south of the hills of Sleeping Giant. Eugene checked in on Christmas Eve, had an unusually good time there and behaved like a model patient. Later, he declared that his stay in Wallingford was a turning point in his life, writing, "If a person is to get to the meaning of life, he must learn to like the facts about himself—ugly as they may seem to his sentimental vanity—before he can lay hold on the truth behind the facts;

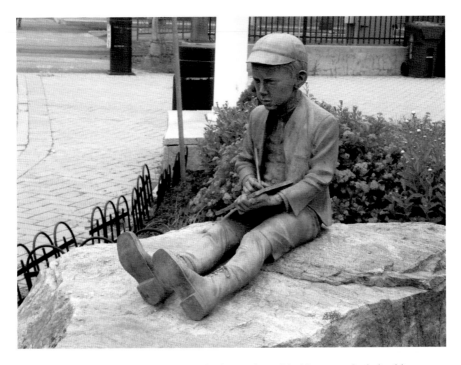

New London honored its Nobel Prize–winning author with this statue, depicting him as a child gazing out over the Thames River. *Photo by Lee Edwards.*

and that truth is never ugly!" He believed that Gaylord had saved him for his future work as a playwright, calling it "the place I was reborn in." Later, he set his play *The Straw* at a version of Gaylord and dedicated a volume of his plays to one of his nurses.

By the time O'Neill returned to New London the following year, he had regained weight and was strong enough to swim naked in Long Island Sound. He stayed that winter in a neighbor's house, where he had the first "ordinary" Christmas of his life, though with someone else's family. Later, he based his only comedy, *Ah Wilderness!*, on this idyllic experience. Leaving Connecticut, he stayed in seedy hotels in New York City, got involved in more failed love affairs and lived in almost complete poverty. He would get drunk in a dark corner at the "Hell Hole" in Greenwich Village too often for his own good. Deciding he had to get out of the city and that New London was no longer an option, he jumped at the chance when an anarchist friend rented a place on Cape Cod. There he met journalist couple John Reed and Louise Bryant. O'Neill would fall in love with Bryant, and they exchanged poems and had an affair for almost two years. He joined

their dramatic group, the Provincetown players, along with Susan Glaspell, Robert Edmond Jones and others. His first real play, *Bound East for Cardiff*, was performed there at the end of a fishing wharf in 1916.

Taking the train between Provincetown and New York, O'Neill wrote play after play, many of which were performed at the Playwright's Theater. *Anna Christie* won him his first of four Pulitzer Prizes in 1922. His plays used rough colloquial dialogue, broken-down, misguided characters and strained domestic situations to create the drama of ordinary life. The 1924 play *Desire Under the Elms* investigates a family of puritanical New Englanders in 1850, torn apart by the adultery of the wife of one of two brothers with the other. Here she confesses:

> *CABOT: Ye'd best lie down a spell (half jocularly) Yer son'll be needin' ye soon. He'd ought t' wake up with a gnashin' appetite, the sound way he's sleepin'.*
> *ABBIE: (shudders—then in a dead voice) He hain't never goin' t'wake up.*
> *CABOT: (jokingly) Takes after me this mornin'. I hain't slept so late in…*
> *ABBIE: He's dead.*
> *CABOT: (stares at her—bewilderedly) What…*
> *ABBIE: I killed him.*
> *CABOT: (stepping back from her—aghast) Air ye drunk—'r crazy—'r…!*
> *ABBIE: (suddenly lifts her head and turns on him—wildly) I killed him, I tell ye! I smothered him. Go up an' see if ye don't b'lieve me!*

O'Neill had moved far beyond the mustache-twirling villains of melodrama, beyond simple ideas of good and evil and into the tragedies of everyday life.

During this period, he bought a farm in Ridgefield and attempted to live a normal life with his wife, Agnes. He wrote, saw a psychoanalyst and drank too much. His father and mother died in 1920 and 1922, while his brother drank himself into madness and died the following year. The entire family he had grown up with in New London had disappeared in the blink of an eye, but the ghosts would haunt him for the rest of his life. In 1926, his other family fell apart as his marriage imploded, just as he began to control his drinking again. He sold the Ridgefield farm and fell in love with a woman who called herself Carlotta Monterrey.

The resulting scandal, divorce and round-the-world "honeymoon" with Carlotta were too public for his taste. "My family's quarrels and tragedies were within," he told his son. "To the outer world we maintained an

indomitable and united front and lied and lied for each other." Did he need these private and public conflicts, these never-ending struggles between the bottle and the pen, between love and desire, in order to write great works? More likely he knew nothing else, no other way of being. The idea that great art only comes from great personal struggle is a myth, but it certainly provides ready-made material.

When he made his Broadway debut in 1920 with *Beyond the Horizon*, he looked out and saw "the woebegone faces of the audience on the opening day" and was sure the play was a "rank failure." But the reviews were fantastic, and he "came to the conclusion that the sad expressions on the playgoers' faces were caused by their feeling the tragedy I had written." Not all of O'Neill's plays were roaring

American drama's golden age began with Eugene O'Neill's gritty, unsympathetically real depictions of everyday conflict. *Photo by Carl van Vechten. Library of Congress.*

successes, and some drifted back into the melodrama that he had hated in his father's work. Nevertheless, he racked up an astonishing four Pulitzer Prizes. He had lost his Catholic faith but produced what many called "the greatest Catholic play of the age," *Days Without End*.

Sinclair Lewis, who had gone to school in Connecticut, said in his own 1930 Nobel Prize acceptance speech that O'Neill deserved it: "He has seen life as not to be neatly arranged in the study of a scholar but as a terrifying, magnificent, and often quite horrible thing akin to the tornado, the earthquake, the devastating fire." The committee took his advice and, six years later, awarded O'Neill the prize as well. He didn't attend the ceremony, though, and even refused to pose for cameramen with the telegram. "To hell with them!" he snarled. He and Carlotta retreated far away from his childhood in Connecticut to a huge estate in northern California, hiding behind electric gates. Carlotta became addicted to potassium bromide, and O'Neill began to experience the symptoms of Parkinson's disease.

He hadn't written anything for years when he sat down during the dark days of World War II and, with shaking hands, wrote *A Long Day's Journey into Night*. It was "written in tears and blood" and, to everyone who knew him,

was obviously autobiographical—a lifetime of pain crumpled into one play. He showed the manuscript to a few close friends, all of whom were shocked at its personal revelations and powerful dialogue. Set in the living room of Monte Cristo Cottage over the period of a long, drunken day, the "Tyrone" family's repressed toxins slowly leak out and poison them. O'Neill gave his own thinly disguised character the name of his long-dead brother, the one his mother never got over losing, and set the play just before his sojourn at Gaylord Farm Sanatorium.

The family calls each other names in front of each other and behind their backs: "hophead," "dirty bastard," "waste" and "fool." It is all the recriminations of a lifetime spent in close quarters, of failed expectations, of failed dreams. As the mother Mary takes morphine upstairs, son Edmund exclaims bitterly:

> *The hardest thing to take is the blank wall she builds around her. Or it's more like a bank of fog in which she hides and loses herself. Deliberately, that's the hell of it! You know something in her does it deliberately—to get beyond our reach, to be rid of us, to forget we're alive! It's as if, in spite of loving us, she hated us!*

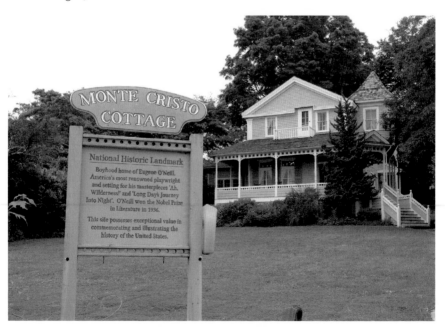

Ghosts of Eugene O'Neill's childhood home of Monte Cristo Cottage inhabit the pages of his greatest work, *Long Day's Journey into Night*. *Photo by Lee Edwards.*

But the play is without any of the trappings of melodrama at all—no deaths, no dramatic entrances, no plot at all. It is just one family tearing each other apart, and every word bleeds true.

The last decade of his life was no easier than the rest. He and Carlotta fought often in private and public, and in 1950, his son Eugene Jr. committed suicide. He did not attend the funeral, racked by Parkinson's, and his own death came at last in 1953. Carlotta buried him in a secret ceremony in Forest Hills, Massachusetts, attended only by his barber and a teacher who liked his work, both of whom watched from a distance. Three years later, Carlotta gave the manuscript of *Long Day's Journey into Night* to Yale University Press, and it became an instant triumph, winning him a posthumous Pulitzer.

In the play, the mother says, "I never should have borne Edmund," and Edmund himself says, "It was a great mistake, my being born a man. I would have been much more successful as a sea gull or a fish." Perhaps O'Neill would have been happier that way, too. But sometimes to be a pioneer means to be unhappy, to rage against the world and your own lot and then to focus that on some great project that cracks open the sky. As Jalal ad-Din Rumi put it so poetically, "The wound is the place where the light enters you." Eugene O'Neill had many wounds, and the light that entered him often burned his brain like fire. But he was able to share some of it with us, and on the page and on the stage, we can still see its gleaming radiance.

Chapter 17

MARIAN ANDERSON

TRANSCENDENT SINGER

Born in 1897 to a family who fled the South after the Civil War, Marian Anderson spent her first years in Philadelphia. At age three, she began to sit at a toy piano, really just metal strips mounted to two blocks of wood, and sing for "more than an hour at a time." At age six, she scrubbed steps and saved enough money to buy a violin. The strings gave out before she did. Luckily, her father acquired a real piano a couple of years later, and she taught herself. At age nine, she started grammar school, but it did not offer formal music classes. So, she took other opportunities to sing, particularly in church choir, where she easily worked her way up to solos. Her sisters were also natural singers, but only Marian had the hunger to pursue this passion.

The opportunities for African Americans, especially females, to get a formal music education were limited. At one school, the secretary told her, "We don't take colored." However, she received ample community support and, by June 1915, gave her first concert at the local Music Fund Hall, where they collected more money for her education. She would sing for five or ten dollars here and there, to earn more. Finally, she hired a tutor and earned enough to attend a high school with a music program.

Her first "reviewed" performance may have been her turn as contralto soloist in Handel's *Messiah* at Philadelphia's Union Baptist Church. *Crisis* magazine mentioned her, saying, "But most exquisite was the dark, sweet, full-blossomed contralto—Marian Anderson, who felt with her soft, strong voice the sorrows of God." At age twenty, she toured the South and the

Midwest, singing gospel spirituals and opera highlights with equal fervor. Her community kept raising money, and she continued her education. About this time, she had a love affair with a man named Orpheus Fisher, and they nearly ran off to get married. But she demurred, remaining devoted to her music.

In 1924, she debuted at the Philharmonic Society at Philadelphia's Academy of Music, the first African American soloist ever invited. A year later, her tutor, Giuseppe Boghetti, entered her in a voice competition in New York, pitting her against three hundred other talented singers. She won, and a concert manager signed her to a contract. He fudged her age, the same way P.T. Barnum had done for Tom Thumb all those years ago. For the rest of her life, Anderson's age was something of a mystery to most audiences.

During those years, not all her performances went well. Sometimes the critics seemed unusually harsh or the audiences failed to appear. In the South, she often had to give two concerts at the same venue, one for black audiences and one for white. She also had to take her place in the Jim Crow restaurants, bathrooms and train cars. So in 1928, she sailed for England, where black artists were experiencing a surge of acceptance and fame.

Her interpretations of the European opera songs were sometimes unconventional, and her "peculiar timbre" was often noted in a negative way by the critics, though none faulted her extraordinary voice and abilities. Back in America at a Carnegie Hall performance a year later with a "regretfully small" audience, one critic praised her "ravishingly supple and jointless legato, flowing like oil," but faulted her "want of ingrained emotional temperament." She continued her lessons, believing that music education was not only for the very young. She learned not to hold back, injecting the tones and emotions of the spiritual into classical arias with impunity.

In 1930, she toured Germany and Scandinavia. In Berlin, she was a huge hit, telling her mother, "The audience refused to leave until they heard more music." And it wasn't just audiences that desired her; a pair of suitors fought over her one night in Berlin. Two years later, she toured northern Europe again, playing 116 concerts in sixty cities and towns during 1934 alone. Her reviews got better and better. In 1935, conductor Arturo Toscanini pronounced that "a voice like hers is heard once in a hundred years." The American press, too, had finally embraced her style, at least in the North, and she was invited to the White House by Franklin and Eleanor Roosevelt. She felt "awe" at the honor, and Eleanor called her voice "beautiful and moving," saying she had never heard "a more finished artist."

By 1939, she was popular, respected and well paid. And then Howard University requested the Daughters of the American Revolution's venue, Constitution Hall, for a concert. As early as the 1920s, the DAR leadership had blacklisted various organizations and people, including Connecticut pioneers Alice Hamilton and Helen Keller. Though Washington, D.C., had the fifth-largest African American population of any American city, the DAR segregated the hall and added a "white artists only" clause. Now they refused Marian Anderson.

Protests ensued, and Eleanor Roosevelt resigned publicly from the DAR. "You had an opportunity to lead in an enlightened way and it seems to me that your organization failed," she said in her article, which was read by millions of people. Anderson read Eleanor's reproach and was shocked that "things had gone so far." The Lincoln Memorial was proposed as a venue instead, and more than seventy-five thousand gathered on the Mall to hear the concert. She was terrified at the weight laid on her but stayed strong, saying, "I could not run away from this situation. If I had anything to offer, I would have to do so now."

Senators, cabinet members and Supreme Court justices were invited, though during that age of segregation and discord only the bravest ones attended. Secretary of the Interior Harold Ickes introduced her, saying, in part, "Genius draws no color line." The event made Anderson a national celebrity, with covers of *Time* and *Newsweek* to follow. Eleanor Roosevelt presented her with the NAACP's Springarn Medal, which she had been scheduled to receive even before the DAR controversy. It took on special meaning now.

Her personal life, so long on the back burner, finally heated up when, in 1940, she agreed to marry her old friend and suitor Orpheus Fisher. They needed a nice place to settle down together, close to New York City, and they bought a one-hundred-acre farm in Danbury with a twelve-room farmhouse for only $18,000. It was a good time to invest in Connecticut real estate. Fisher bought furniture and fixed the place up while Marian was on tour singing for troops during World War II. In the early 1940s, the newly named "Marianna Farm" flourished. Her new studio was built, with a flat roof for a sun deck. It became a refuge from both the racial tensions and anxieties of celebrity. Cows, sheep, pigs and chickens filled up the barns and sheds, making it a real working farm. After waiting for the celebrity gossip to die down, Anderson and Fisher had a small wedding at nearby Bethel Methodist Church.

She began recording in the studio, bringing fellow opera singer Edyth Walker to help her adjust her aging vocal cords. Her home life in Danbury

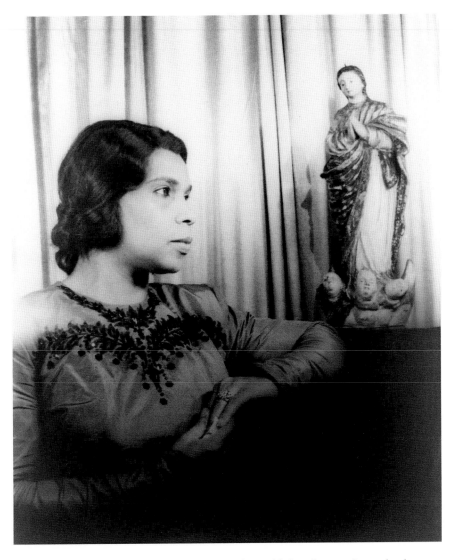

Marian Anderson became America's most popular and beloved opera singer, despite the racial barriers set in her way. *Library of Congress, Prints & Photographs Division, Carl Van Vechten Collection.*

seemed to mellow her out, too, and she became more comfortable on stage. Critics noticed, calling her performances "warmer." Once, after a dangerous operation to remove a cyst, she returned to her studio with fear in her heart. "A brook runs by it," she told a correspondent. "It is very quiet. An occasional wind in the trees is the only sound. Suddenly, I knew

in my heart that I would sing again." Happiness can breed confidence, and her Connecticut home made her profoundly happy.

In 1942, the DAR invited her to appear in Constitution Hall as a benefit for war relief, trying to make up for its earlier failure. Anderson agreed, but only if the seating was not segregated. The repentant leadership of the DAR agreed to this proviso, and she sold out the hall. Eleven years later, she sang again at Constitution Hall to an integrated crowd. "There was no sense of triumph," she said. "I felt that it was a beautiful concert hall, and I was happy to sing in it."

Though she had been the biggest opera star in America for decades, she had not sung at the Metropolitan Opera House. In fact, no black performer had sung there, even though other New York City venues had long been welcoming. She would have to act in the opera, too, though, something she was not nearly as comfortable with. However, "I felt incredibly alive," she exulted. On January 7, 1955, she played Ulrica in Verdi's opera *Un Ballo in Maschera*, becoming the first African American to sing at this fabled opera house in seventy-one years. But this was not just symbolism. Like her performance at the Lincoln Memorial, it was noticed not just by Americans reeling from *Brown v. the Board of Education* but by many countries around the world.

President Eisenhower certainly took note and asked Anderson to be part of a cultural exchange, sending her to Cambodia, the Philippines and Hong Kong. India's prime minister, Jawaharlal Nehru, invited her to his house. She served as an ambassador to the United Nations, and her autobiography *My Lord, What a Morning* came out to great reviews. She continued to tour the Americas, Asia, Europe and beyond. She toured Israel, singing in Hebrew, to the delight of the locals.

She "retired" in 1959 at age sixty-two, citing the deterioration of her voice. While an aging rock-and-roll singer might scream her way through her losses, the public expected the best, clearest and most precise singing from someone like Anderson. Nevertheless, she sang "The Star-Spangled Banner" at John F. Kennedy's inauguration and toured Australia and New Zealand in 1962. Lyndon Johnson set up an integrated concert in San Antonio, Texas, in 1963, featuring Anderson as the star attraction. Dr. Martin Luther King slated her to sing "The Star-Spangled Banner" at the Lincoln Memorial for his famous march, but the huge crowds prevented her from arriving in time. However, she finally got to the stage and sang "He's Got the Whole World in His Hands," one of her most popular requests.

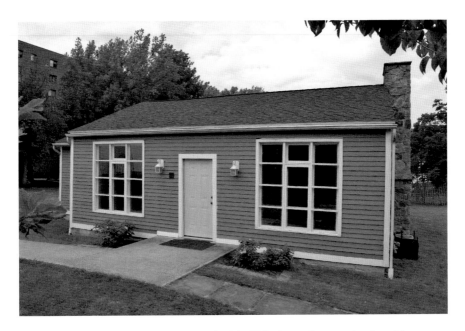

Marian Anderson built this studio at her cherished Marianna Farm, and today, visitors can see it at the Danbury Museum and Historical Society. *Courtesy of the author.*

She was awarded the Presidential Medal of Freedom, but it was a somber ceremony, coming two weeks after Kennedy's assassination. Shortly afterward, she retired again, giving a farewell tour in the fall of 1964 and spring of 1965. She continued to serve as a cultural ambassador, in 1966 going to Dakar. Throughout the 1960s, she narrated Aaron Copland's *A Lincoln Portrait*, giving live readings that transfixed audiences. It was remarkable for any performer to continue into her sixties and seventies, but she could not seem to give up the music.

In 1975, her husband suffered two strokes, and Anderson herself began to slow down. Two years later, her seventy-fifth birthday occasioned a celebration at Carnegie Hall. However, since her manager had lied about her age many years earlier, she was in truth eighty years old. More awards followed, but her public appearances slowed down even more, particularly after Orpheus Fisher died at nearby Danbury Hospital in 1986. Three years later, the Charles Ives Center in Danbury raised money for the endowment of an award in her name, bringing these two Connecticut musicians together. She finally passed away in 1993.

Her performances moved people. That word *move* implies shift, and as America's most famous and popular singer, she shifted the way people felt

about race, about "classical" music, about the limits of performance. "One knows that later, when there has been time to absorb these great happenings, their impact will be even greater," she said once. Sometimes history asks something of you, and when it does, you must step up to the microphone and sing your heart out.

Chapter 18

ALEXANDER CALDER

SINGULAR SCULPTOR

Sandy Calder needed a place to build his sculptures—a big place, with a barn and a yard. He had visited Connecticut eight years earlier in 1926, when at a friend's house on Lake Candlewood he carved a wooden sculpture out of an oak fence post, calling it *Flat Cat*. So he searched the Depression-wrecked rural farmlands of western Connecticut and finally found a cheap house in Roxbury. Over the previous decade, he had made a splash in the Paris art world, but he was still so poor that he needed to borrow money from a friend for a down payment. He rebuilt the hearth in the old icehouse, set up a workshop and proceeded to change art forever.

Born in 1898 in Pennsylvania, Alexander Calder came from a family steeped in the arts: his father and grandfather were sculptors and his mother a professional portraitist. This background allowed him to learn the basics early and move quickly to new ideas, new forms. He made jewelry for his sister's dolls, built mechanical trains with a family friend and sculpted dogs and ducks for his parents. "I took these activities as a matter of fact," he said. Nevertheless, his parents knew how difficult the life of an artist could be, so they encouraged him to become a mechanical engineer. He also trained for the army in 1918, but the war ended before he saw any service. He then bounced through jobs as a hydraulic engineer, draughtsman and mechanic, continuing the nomadic lifestyle he was accustomed to, until one day in the mountains of the Pacific Northwest, he realized that he had missed his true calling.

Back on the East Coast, he studied with mentors like Thomas Hart Benton and George Luks and then, in 1926, moved to Paris, establishing his first studio in Montparnasse. He rubbed up against people on the cutting edge of the art world who inspired him to push boundaries. On seeing Auguste Rodin's famous sculpture *The Kiss*, he complained to a friend about the "marble mousse" that the two figures grew out of. Clearly, traditional sculptural arts were not for him.

He began fashioning mechanical objects and slowly built his "Cirque Calder," a fascinating miniature circus created from found items. "I was working in a medium I had known since a child," he said, seeing no problem with combining toymaking with "high art." The avant-garde Parisians loved his humorous jauntiness, and he continued to experiment, fashioning sculptures from metal and creating "kinetic art," which could be operated by hand or even motorized. In one of these, wire goldfish swam through wire bowls when you turned a crank. He asked innovative artist Marcel Duchamp what he should call them, and the Frenchman replied with a characteristic shrug, "Mobiles." In doing so, Calder created some of the earliest "non-static" sculptures, moving the form in new aesthetic and physical directions.

He drove around Paris on an orange bicycle, wearing gray knickers and red socks, looking more like an overgrown teen than an artist who had sold his first sculptures. A visit to Piet Mondrian's stunningly designed studio in Paris turned him onto the use of bright, solid colors, and he would infuse these elements into future pieces. His face's permanent scowl was balanced by a relentlessly mischievous smile, and his good nature attracted lots of attention. In 1931, after a chance meeting on a boat, he married Louisa James, grand-niece of the famous brothers Henry and William, and began to think about moving back to America to foster both a family and much larger sculptures.

In Roxbury, Calder and his wife, Louisa, fixed the house, drank wine and taught their children the accordion. In the studio, his technical abilities leaped ahead as he continued to make more abstract work, continuing to incorporate more humor than many artists found in the discipline. He also settled into a distinctive idiom—metal. "Sculptors of all places and climates have used what came ready to hand," he said. "They did not search for exotic and precious materials. It was their knowledge and invention which gave value to the result of their labors." He shifted from experimenting with the surrealists and building a charming circus to making massive installations that pushed conceptual boundaries.

Alexander Calder's playful sense of humor made him one of the most original artists of the twentieth century. *Library of Congress, Prints & Photographs Division, Carl Van Vechten Collection.*

In Connecticut, his sculptures became more free-form and could move in many ways depending on the wind, rather than in a controlled manner by a crank or motor. As he had hoped, larger mobiles and wind-driven pieces were possible on the farm as they never had been in a small Paris studio. He began by hammering and shaping a piece, which he then assembled with others, giving them names like *Steel Fish* and *Morning Star*. He painted them carefully in bold colors, using vises and monkey wrenches to connect them with bent but sturdy wire. A candy-like oblong of red might swing free in the space between two white, squashed ellipses, all hanging delicately in midair like tiny worlds, moving slowly in the wind. Many pieces had the appearance of gigantic toys, so it was no surprise when later in the century, companies began mass producing versions of these "mobiles" for hanging above children's beds.

Calder's fame grew, but he still had problems selling his work. The Museum of Modern Art bought its first mobile for a whopping sixty dollars in 1934. Soon, though, his new Connecticut neighbors at the Wadsworth Atheneum started buying and exhibiting his work. He continued making mobiles, smaller jewelry-like objects that could be sold more easily and quickly and large wire sculptures that combined various techniques. He tried his hand at print-making and illustrated books. And he built a new, better studio with more light, which quickly became cluttered with a thousand geometric objects. Beautiful reds, yellows, blacks and whites gently moved in a planetary dance until the wind rushed through, clanging and smashing various pieces together.

After experimenting for a few years, Calder solved various problems, like how to deal with strong winds. He began to enlist others to help him create larger and larger scale projects, filling the former farm with bolted sheets of heavy metal, called "stabiles," climbing on ladders and using cranes. These beautiful wire and metal sculptures were both delicate and skeletal and at the same time threatening and authoritative. "Disparity in form, color, size, weight, motion is what makes a composition, and if this is allowed, then the number of elements can be very few," Calder said. "Symmetry and order do not make a composition. It is the apparent accident to regularity which the artist actually controls by which he makes or mars a work."

During World War II, metal was hard to come by, so he carved wood instead, although at one point he cut up his aluminum boat for material, shaping and carving the wood and connecting it with wire in pieces he called "constellations." In 1946, his work was shown in Paris, and philosopher Jean-Paul Sartre wrote the text of the catalogue for the show. By 1951, he began building "towers," combinations of stabiles and mobiles, often attached to a wall or other surface, with movable objects suspended from them. A large red stabile built of sheets of aluminum could have a weather vane of circles that spun and turned in all directions.

By the 1950s, he was taking commissions for the huge monumental stabiles from airports, museums and events like the Olympics. One huge example, the fifty-foot-high orange *Stegosaurus* next to the Wadsworth Atheneum, was made of steel plates put together in nearby Waterbury. He painted gouaches, drew illustrations for books like *Aesop's Fables* and made poster prints to protest the Vietnam War. He painted one-of-a-kind cars and even an airplane. He made two thousand pieces of jewelry for friends and admirers, from Georgia O'Keefe to Peggy Guggenheim.

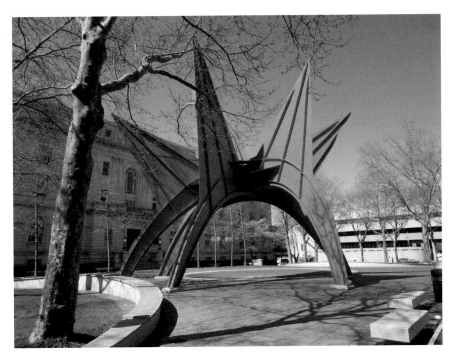

The sculpture *Stegosaurus* at the Wadsworth Atheneum is a bold example of one of Alexander Calder's monumental stabiles. *Photo by Trena Lehman.*

He and Louisa often visited with neighbors like the critic Malcolm Cowley or playwright Arthur Miller, who had come to Roxbury to write *Death of a Salesman* and stayed for the rest of his long life. Yves Tanguy and Andre Masson visited Calder in Connecticut, renting houses and enjoying the literary and artistic community springing up in the western hills. Then, in 1963, Calder built another workshop in France so that his monumental European sculptures did not need to be shipped across the Atlantic. The stabiles kept growing and became some of the most recognizable public art anywhere, soaring into the skies above parks and squares in city after city.

By the 1970s, Calder had earned both popularity and critical acclaim, with retrospectives of his work being held all over the world. The sculpture *Bent Propeller* was installed at the World Trade Center, later to be destroyed on September 11, 2001. His last work, *Mountains and Clouds*, was an enormous combination mobile and stabile, destined for the atrium of the Senate Office Building in Washington, D.C. He would not live to see it completed, and after passing away in 1976, he was buried near the Roxbury home he loved.

As the decades have passed, Calder's works continued to gain value and sell for millions of dollars. More importantly, his methods and aesthetics became part of the history of art, and thousands of young sculptors followed in his footsteps. He proved that sculpture did not have to remain in the forms and materials of the past but could anticipate the future. He proved that metal could move and ideas could soar.

Chapter 19

KATHARINE HEPBURN

ONE-OF-A-KIND ACTOR

Born in Hartford in 1907, Katharine Hepburn was always adventurous. Once, she climbed a hemlock tree in the yard and her surgeon father challenged her to go farther. A neighbor called after noticing how high she had clambered. "Just don't say anything," the doctor replied. "You see, she doesn't know it's dangerous." She often preferred to think of herself as a boy, because boys seemed to have so much freedom. After all, her brothers walked on the roof of the nearby Mark Twain house. She could, too. "I was a tomboy," she said. "I could out dive, out swim, out run, out climb anybody." She rode a boy's bicycle until the day she died.

After 1910, the family lived in Charles Dudley Warner's old house on Hawthorn Street. Her mother spent her time taking photos of decaying factories and brothels, urging the city and state government to act. She even led a delegation to meet President Woodrow Wilson. Young Kate was inspired by having such an activist mother. "Hartford is where I first learned about the importance of being sure I did the best I could do," she said later. Her mother almost ran for senator, as well, but Dr. Hepburn threatened divorce. There were still limits to female empowerment.

Their summer house in the Fenwick area of Old Saybrook was what people in New England call a "cottage" but was, in truth, a multi-story house. Still, it had an outhouse and creaking floor boards and an old-fashioned icebox. From the front porch, Kate enjoyed views of the lighthouses at the mouth of the Connecticut River. But it was not always an idyllic existence. When she was thirteen, her brother Tom hanged himself for unknown reasons.

At Bryn Mawr College, she found that she had few study skills and "was really not at home or at ease." Her freckles and skinny legs continued to plague her; she often felt like the ugly duckling and a tomboy among so many cultured women. In 1926, she finally made friends, started smoking and nearly won the Connecticut golf championship. "I'm going to be an actress," she told her parents after graduation. They were not pleased. Worse, she had fallen in love with poet Howard Phelps Putnam, even though he was married. Unsurprisingly, things with Putnam did not work out, and she promptly married Ludlow Ogden Smith in 1928, even though they had almost no physical relationship. "I have loved and been in love. There's a big difference," she said ruefully years later.

Meanwhile, she paid her dues in a touring cabaret show, won a role in a play at the Shubert Theatre and got bit parts and understudy roles in plays around New England. She performed every night on stage, learning the craft quickly, and took voice lessons from an opera singer. Soon she got leading roles in four plays at the Ivoryton Playhouse upriver from Fenwick. Even her parents grudgingly admitted that she was getting better at this strange craft. By the time Hollywood came calling, she was much older than the usual ingenue, with several years of intense stage experience.

Her first film and hit was *A Bill of Divorcement*, for which she was paid five times what Bette Davis had gotten the year before, as much as the director George Cukor, who became one of her great friends. The *Los Angeles Times* wrote, "Unless all signs fail, Miss Hepburn will withstand the efforts of any studio to trick her eyebrows into disturbing angles or publicize her as a hothouse orchid. Character and intelligence are reflected in every word she utters and every gesture, yet she is human, appealing, and girlishly sympathetic." In other words, you could be feminine and yet brilliant and strong. This was something of a revelation for both the film industry and for America.

Despite her reputation as aristocratic and aloof, she threw her heart into each role. In *Little Women*, during the agonizing scene in which Beth dies, Hepburn wept onscreen and was sick in her dressing room. Her portrayal of Jo as a tomboy who wants love appealed to everyone, and the film broke all box office records to that date. That same year, she won her first Academy Award for *Morning Glory*, but she didn't go to the awards ceremony. Already, stardom had begun to feel like a burden. Instead, she continued to work in theater, starring in *The Lake* on Broadway. But the play failed miserably, and sharp-tongued critic Dorothy Parker quipped that Hepburn "ran the gamut of emotions from A to B."

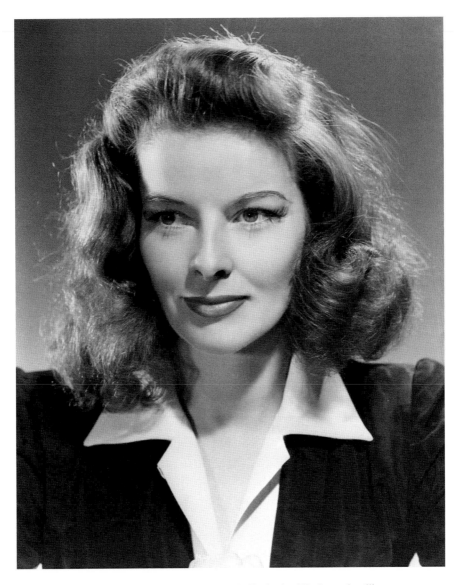

Movie studios often tried to label and pigeonhole Katharine Hepburn, but like everyone else, they failed. *Metro Goldwyn Mayer Publicity Still.*

She traveled to Mexico to file for divorce from her husband and would never marry again, though agents, reporters and producers linked her to various men. Being unmarried was not a problem for Hollywood, of course, and in fact may have helped her career. However, during the 1930s and beyond, she wore pants off and on-screen. And with her wry grin, sharp

remarks and steel spine, Hepburn was an uncomfortable societal change embodied. "I put on pants fifty years ago," she said in 1981, "and declared a sort of middle road." That "middle road" was considered sinful and wrong by huge numbers of Americans, not to mention the infamous "Production Code," which warned against "trousered women." Rumors abounded that she and her friend Laura Harding were more than just friends, rumors that would follow her for decades. While her sexual ambiguity sometimes played well on the screen, the gossip made her avoid the Los Angeles high life and retreat to Old Saybrook, where the people accepted and protected her.

With the exception of *Alice Adams*, in which she played a character close to herself, a series of box office flops followed success. Hollywood could bend, but not break, and when she played a gender-switching con artist in *Sylvia Scarlett*, it was a disaster top to bottom. On the set of *Mary of Scotland*, she fell in love with legendary director John Ford, one in a line of hard-drinking older men that would continue with Spencer Tracy. Ford called her "half pagan, half puritan," possibly the best assessment of her personality ever made. Famed aviator and millionaire Howard Hughes taught her to fly and even came to Fenwick, where she installed an indoor shower for his convenience. But no one stuck, not even her female friends, who seemed to last five or six years and then disappear. Her loyalty was to her career, not to love.

Then came *Bringing up Baby*, a monumental achievement, one of the funniest movies of all time. But more startling was that Hepburn was able to push the boundaries of "acceptable" female behavior. Her character infuriated everyone, defeated every man she encountered and at the same time was completely lovable. However, at first the film did not do well at the box office and continued her reputation as "box office poison." Unfortunately, it would not be the biggest disaster for Hepburn that year.

On September 21, 1938, Hepburn took her usual swim in Long Island Sound and played a round of golf, even though four days of rain had soaked the greens. She actually shot a hole in one on the ninth hole. At 2:00 p.m., rain splashed down again, and wind began driving the water straight up onto the beaches, pushing it ten feet higher than normal. The same wind lifted her car and flung it like a toy. A chimney collapsed. Finally, the family roped up and crossed through what had been a field and was now a lagoon. As they reached relative safety, they saw the house rip off its foundations and sail off into the Sound.

After the hurricane, she picked up a shovel and dug out what family heirlooms she could from the sand and rebuilt the house. Her new bedroom

windows faced south and east, so she could see the lighthouses at the mouth of the river and the wide expanse of the Sound. Meanwhile, she had bought the rights to *The Philadelphia Story*, whose main character, Tracy Lord, was inspired by a Main-Line socialite but written with Hepburn in mind. She acted in the play on Broadway and then in the film. It became a huge hit and showcased her gift for witty repartee. She was nominated for another Oscar and won other awards for her performance.

She followed it up with *Woman of the Year* alongside one of her great loves, Spencer Tracy, beginning a string of romantic comedies. However, her movies failed as often as they succeeded. Movies are a bit like architecture, where everything has to work together. But she had learned that whether a film made millions or hundreds of dollars, the important thing was the craft. She wanted to be an actor, not a celebrity, and she did everything to confound the celebrity machine that P.T. Barnum had pioneered one hundred years earlier.

She occasionally got involved in politics, like when she spoke out against censorship during the witch hunts of the House Committee on Un-American Activities. But she had decided that her real work was acting, and her work

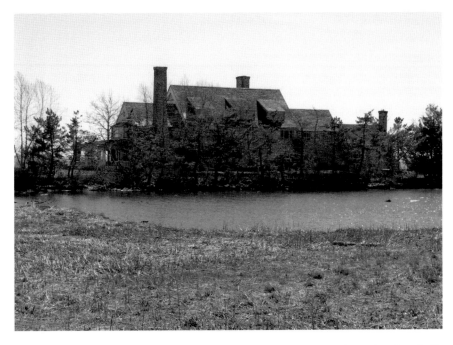

Katharine Hepburn's house in Fenwick was destroyed in the 1938 hurricane, but she rebuilt it, refusing to leave Connecticut. *Photo by Lee Edwards.*

there produced amazing results. "The actor can escape into creation," she said. In her forties, she continued to try to stretch her boundaries, evaluate her work and improve as an actor. After a conversation with director David Lean on the set of *Summertime*, she upbraided herself, calling herself "careless." "You did not get to the essence of things," she told herself. "It's a bit late now, but profit by this—if you do it—do it. Get those weeds out. And plant carefully." She turned out stellar performances in *The African Queen* with Humphrey Bogart and in a film version of *Long Day's Journey into Night* by Connecticut playwright Eugene O'Neill. In the late 1950s, she commuted down I-95 to the Shakespeare Festival Theater in Stratford to play Portia and Beatrice.

Back in Old Saybrook, she often rode her bicycle through town, stopping at the James Pharmacy for ice cream. She canoed in the salt marshes and across the river to Old Lyme. She played tennis on the Fenwick courts in the summer and the occasional round of golf on the course nearby. Her rooms were stacked with books, and she read voraciously. She continued making films, earning two Oscars in two years for *Guess Who's Coming to Dinner* and *The Lion in Winter*. In 1976, she added a projection room to the Fenwick house and was pleasantly surprised by her performances in many of the earlier movies, now decades in the past.

She wasn't the only one. In the 1970s, there was a revival of her "edgy" films of the 1930s. People began to realize that she had been a pioneer; even her "flop" *Sylvia Scarlett* became a cult classic. Critics who had lambasted her four decades earlier now hailed her as a brilliant comedian and artist. Then, in 1981, *On Golden Pond* won Hepburn a record fourth Oscar. By now, many were calling her the greatest actress of the century, and few could dispute it.

Even after that triumph, she continued to act, even though Hollywood's gossips shrugged at this old lady who "should have gone out on top." When she died in 2003, the news vans converged on Fenwick, and the town closed ranks to protect her one more time. Connecticut had given her the strength to go out and be a star, but it also gave her permission to be the woman she preferred to be, an eccentric old Swamp Yankee who loved to wear sweatpants and sneakers.

Whatever her effects on gender roles and feminine self-image, she was certainly the first great female actor, changing the roles for women in America's most popular art form. She did it by being her unique self, telling everyone, as she often did, "Try to figure me out. You'll never get it right."

Chapter 20

BENJAMIN SPOCK

PIONEERING PEDIATRICIAN

Benjamin Spock was born at home in New Haven in 1903, soon to be the eldest of six children. "It was certainly a child-centered family," he said. He sat at the "children's table" until age eleven and had three tonsillectomies. His father was a lawyer for the New Haven and Hartford Railroad and gave "Bennie" an allowance for doing chores like keeping the coal furnace going. His mother was "too strict, too moralistic" and had a number of "unconventional" views about child-rearing, like forcing his sisters to wear gray angora bonnets. Few of these ideas would make it into Spock's pioneering book decades later, but exceptions were early bedtime and fresh air. He later became skeptical about them, as well.

The neighborhood at the base of East Rock swarmed with children, and the Spock backyard included a seesaw, sandbox and swing, making it a popular gathering place. He and his siblings and friends hunted for frogs on the nearby Mill River and sledded on the slopes of Science Hill. His family still used a horse-drawn carriage to get to the railway station, and when he attended Hopkins Grammar School, he walked a mile and a half each day. He only lasted a year there before switching to Hamden Hall, trudging up the long hill past the old Whitney Factory. Shooting up to over six feet tall, he played soccer and baseball, but neither brought out the athletic skill he would later demonstrate.

After two years at Phillips Andover Academy, he came back to New Haven to attend Yale in 1921. He joined the crew team and practiced this unfamiliar sport on the Housatonic River in Derby, using his long arms to

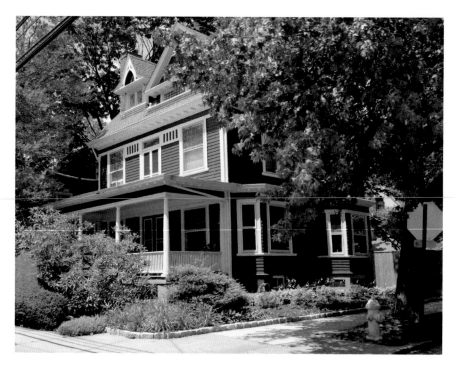

In his childhood home in New Haven, Benjamin Spock first learned the dos and don'ts of childcare. *Courtesy of the author.*

pull the oars. The Yale team had not been doing well, but with Spock, they edged out Harvard and won the Olympic trials. They went to Paris for the Games and won the gold medal by over three boat lengths. However, it would not be as an athlete that Spock gained his place in history.

During summer breaks, he worked at the Newington Crippled Children's Home, and it inspired him to go to medical school to study pediatrics. His grades averaged only a C+, but medical schools in those days weren't as picky as today. After some time at Yale, he met Jane Cheney, and they moved to New York City together. Transferring to Columbia, he found that there was no psychological training in pediatrics. In fact, there was little of it in the entire country. At the Payne Whitney Clinic, one floor was "given over to children's psychiatry," but when Spock worked there, he only had two cases in ten months.

In 1933, he set up private practice on East Seventy-Second Street, making house visits, all the while taking psychoanalytic classes. He learned the current theories of schoolteachers, nurses and psychiatrists, absorbing

it all and applying it to his practice. He realized that parents often caused the very problems they feared. Meanwhile, Jane had their first child, and he applied the classic methods from books like Henry Holt's *The Care and Feeding of Children*, which had influenced his mother's generation. He made all the usual mistakes, like giving his son toys he had always wanted and complaining when the child played with them "wrongly." He also had the same problems doctors always have balancing home and work life, paying attention to other people's children and not his own.

During World War II, he signed up for the Naval Reserve, even though he had a lung condition that exempted him, and rose to the rank of lieutenant commander. In 1944, his second son was born, and by that time, his ideas about raising babies had definitely changed. In fact, he had begun to write a book about it. An editor had approached him earlier to write a book for parents, but "I didn't know enough," he said. Five years later, another editor did the same, and this time he was ready. "My purpose was not to advocate a theory," he said, "but primarily to tell parents what children are like, including descriptions of their unconscious desires."

Going for twenty-five cents, *The Commonsense Book of Baby and Child Care* sold 750,000 copies in the first year, without a penny spent on advertising. Even though his advice was in some respects the opposite of what his own mother had advocated, she read the book and told him, "Benny, I think it's quite sensible." It shifted parents from "control" of children to "guidance," and readers loved that it didn't "talk down" to them, translating complex psychological theories into practical applications. His opening line, "Trust yourself! You know more than you think you do," was paraphrased from Ralph Waldo Emerson and resonated with twentieth-century Americans concerned about their own fitness as parents.

However, his idea that although routines were good for a child, a parent could feed him or her outside "scheduled" feedings was called "too permissive" by critics. Most shocking to modern readers is that his "radical" idea that babies need love was considered by previous experts to be false. But he was working against long-held beliefs that too much kissing or cuddling would "spoil" a baby. He gave advice on things like toilet training and how to arrange the household to prevent accidents but also insisted each child should be treated as an individual.

He spent the following decade teaching at several universities and writing about the new approaches for raising children in magazines like *Redbook* and *Ladies' Home Journal*. During the 1960s, though, he "stuck his neck out" in politics, campaigning for John F. Kennedy and Lyndon Johnson

Benjamin Spock risked
the success he gained by
advancing childcare methods
when he involved himself in
politics but never regretted it.
Nationaal Archief Nederlands.

and then falling out with them over nuclear weapons and the Vietnam War. He was arrested for an act of civil disobedience against the war in October 1967 and again in 1971. Joining these sorts of political fights may have been the right thing to do, but it made many people question his work in childcare. Vice President Spiro Agnew called him a "corrupter of youth" and blamed his "soft methods" for the "hippies." But Spock saw little difference between helping children by advocating methods of baby care or by saving them from atomic bombs. So he risked his legacy time and time again.

He continued to get involved with politics, getting on the ballot in ten states as a presidential candidate in 1972. Three years later, he and his wife separated, and shortly thereafter, he married a younger woman, activist Mary Morgan. During those years, he also reevaluated some of the sexist attitudes present in *Baby and Child Care*, realizing that he had internalized the attitudes of his parents' generation more than he thought. He changed other things, too, like whether or not to let a baby sleep on its stomach. Good science is always re-evaluating, testing, moving forward. After all,

one of the central tenets of the book was that ideas about good parenting should evolve over time.

Spock's book sold over fifty million copies in the twentieth century, influencing generations of parents and their children. He had started a conversation about practices that had remained virtually unchanged for thousands of years. And those of us born in an age in which love and flexibility are the watchwords of childhood, rather than austerity and punishment, can thank him for it.

ELLA T. GRASSO

GROUNDBREAKING GOVERNOR

Ella Rosa Giovanna Oliva Tambussi could hardly have had a more Italian name. Her parents, Maria and James, had both emigrated separately from the "old country" just after the turn of the century and settled in Windsor Locks, Connecticut. Her father found work in a machine shop nearby, and little Ella "would rush out to meet him" on his way home from work. "I would tell him all my secrets and he would listen patiently and kindly." He taught her "respect for others," "persistence" and "that one does not abandon a task." Her mother also worked in a mill and at a machine shop, and Ella inherited her blistering temperament and sharp tongue.

As an only child, Ella was encouraged to go to school, and the little girl spent long hours in the town's library but never read a book about a woman serving as a leader, stating wryly that "there were no books in the Windsor Locks Library on the subject." Of course, women had gained the right to vote in national elections when the Nineteenth Amendment was passed only weeks after Ella's birth. Sadly, though the state had a long history of women's rights advocates, from Catharine Beecher to Charlotte Perkins Gilman, Connecticut's male politicians of the time did not agree. Indeed, one of Connecticut's U.S. senators thought women should not vote and instead "go home and knit bandages and pick lint."

In 1932, at age thirteen, Ella won a scholarship to the Chaffee School and found herself among wealthy children, far from her Italian working-class roots. But immediately, according to another student, "she began to show great prowess at leadership with a great big lot of common sense thrown

in." She also met a young man named Thomas Grasso, who was studying at Central Connecticut State. He saw her at the beach at Old Lyme, reading Shakespeare's *As You Like It*. They began a friendship, though Tom hoped for something more romantic.

Meanwhile, she did so well at school that she was accepted by the all-female Mount Holyoke College. She continued to excel there, even participating in a program called the Hudson Shore with Eleanor Roosevelt, who became a lifelong idol. She went on to get a master's in economics at Holyoke, putting off marriage with the long-suffering Tom Grasso once again. But he didn't have to wait much longer—after her graduation, she wed her "best friend," the beginning of a happy, lifelong marriage.

It was a difficult time for the state, having struggled through the Depression and now World War II. Governor Wilbur Cross said at the time, "It is the energy of intelligent, aggressive, and well-trained young men and women in practical efforts" that would keep democracy running. Ella Grasso eagerly answered that call, joining the public sector at the lowest level possible, as interviewer grade 1. But she was soon promoted to assistant director of research for the War Manpower Commission of Connecticut and entered politics obliquely in 1942 by joining the League of Women Voters. However, she spent years working in government before switching from registered Republican to Democrat in 1951, a year before she ran for office as state representative from Windsor Locks.

After a tough primary battle against her neighbor, who tried to use her party switch against her, she won the general election and began focusing on abolishing Connecticut's county government system in order to eliminate the duplication of services. She was one of forty-three women to be elected to the House that year, though none served yet in the Senate. She put in a lot of hard work, won the notice of the veteran legislators and was elected as floor leader in 1955. She was building a reputation as a "good government" politician who wanted a small, efficient bureaucracy that helped everyone earn a decent living. She also earned a reputation for integrity, compromise and a willingness to listen.

However, she was also one of the toughest people, man or woman, that anyone could imagine. Everyone who remembers her today, fondly or otherwise, speaks of her biting comments, her razor-sharp wit and her colorful language. At the time, male politicians sometimes called her "shrill" or "emotional," even as she worked practically and steadily toward achievable goals. Her office became known as "the clubhouse," where people gathered to chat frankly about the issues of the day.

Despite a primary challenge from her own lieutenant governor, who was looking for revenge after his defeat in 1974, she was reelected later that year with no difficulty. People began to talk about Grasso as a possible candidate for vice president. And then, disaster. She was diagnosed with ovarian cancer, and it was terminal. She decided to resign and on the last day of 1980 told the public, "Regretfully, it is my belief that I do not have the stamina or the endurance for the rigors of the new legislative session and the myriad of problems that face the administration of a vital and vibrant state....I love you. I love you all." A little over a month later, on February 5, she died, one of the public's fiercest servants, taken too soon.

Even successful politicians acquire few lasting rewards—a statue here, a street christened after you there. A medal, an honorary degree, a renamed school. Maybe a hall of fame or two if you're lucky. For a while you may live in the memory of your constituents and those you served with. You can expect only contempt or grudging respect from members of other political parties. But some people decide to serve anyway, and Connecticut has had more than its fair share of great Republican, Democratic and Federalist governors over the centuries. What makes that so surprising is that we are not an easy group to satisfy.

After her death, Ella T. Grasso was given all the honors listed above and more. She had broken a glass ceiling of a position that now seems natural for any woman to have. But perhaps none of that would have meant as much to her as the things she had done to help the citizens of Connecticut. And she did them, as people said of Ginger Rogers, "backwards and in high heels."

Chapter 22

SOL LeWITT

ICONOCLASTIC ARTIST

B orn in Hartford in 1928, Solomon LeWitt was the son of two Russian Jewish parents, a doctor and nurse, who had emigrated at the turn of the century. Sol's father died when he was only six, and his mother moved with her young son to New Britain. He worked in his aunt's store and drew on the wrapping paper lying around. Once, his mother scribbled a black circle and prompted him to do the same, in an uncanny forecast of his future.

She must have noticed his interest in art because she took him to classes at the Wadsworth Atheneum, a haven for avant-garde painting in those years. At New Britain High School, he decided on the graphic arts as a career and was accepted to Syracuse University as an art major. When he graduated in 1949, he was competent enough to win a Tiffany grant but was drafted for the Korean War in 1951. He served his time in "Special Services" making posters. After the war, he moved to the Lower East Side of Manhattan, attending the Cartoonists and Illustrators School, finding work at magazines and eventually with the young I.M. Pei's architectural firm as a graphic designer. It may have been his work with Pei that helped him see his way toward his very practical, architectural-plan-style of conceptual art.

After quitting his job to make art full time, he spent two years barely scraping by, until he finally took another job selling books at the Museum of Modern Art. The prevailing artistic style at the time was Abstract Expressionism, and LeWitt and his friends did not like it, finding it "pervasive but useless." Inspired by the new artists showing at the museum—Frank

Stella and Jasper Johns in particular—he began searching for "the building blocks of form," as people like Picasso and Cezanne had done before him. But he found more than that—some basic truth about art itself. As he put it later, "Ideas can be works of art; they are in a chain of development that may eventually find some form."

He began making sculptural reliefs, paintings and three-dimensional works with geometric designs, simplifying and stripping down the surfaces and removing detail and elaboration. Unlike "pop artists" such as Andy Warhol and Robert Rauschenberg, LeWitt had found a different path, one of "linear and skeletal" structure that used precision and mathematical ratios. An artist, according to him, must make "some irrational leap into the unknown." But he took his time coming up with his own technique and aesthetic and was forty years old when he first came up with his own style.

After working on modular sculpture in the mid-'60s, he had achieved methodical, minimalist art that brought him into the galleries and drew the attention of the art world. His industrially fabricated pieces were included in a 1966 exhibition at New York's Jewish Museum. Now one of the leaders of the "conceptual" movement, LeWitt wrote a very short manifesto, "Paragraphs on Conceptual Art." "Conceptual art is made to engage the mind of the viewer," he wrote, "rather than his eye or emotions."

At a fellow artist's apartment, he took a chess board and placed it on the wall, using it to draw a square. Then he filled this space with diagonal lines. This modest exercise may have been the first of his celebrated wall drawings. In 1968 at the Paula Cooper Gallery in New York, he drew on the wall, using a pencil to draft a system of parallel lines in four different directions. He knew that when the exhibit was over, his art would be painted over. No one could "buy" that particular work of art. Instead, people could use the instructions he wrote out to re-create the work on other walls. This was art in the public domain, art that could be reproduced like modular homes or lamps. It was nearly unheard idea for an "artist," though architects, composers and craftspeople had long since taken it up.

To allow others to do this, he wrote out instructions. Some were drawn like maps that you might encounter while assembling origami or furniture; some were simple paragraphs. *Serial Project No. 1* from 1968 states, in part, "A set of nine pieces is placed in four groups. Each group comprises variations on open or closed forms. The premise is to place one form within another and include all major variations in two and three dimensions. This is to be done in the most succinct manner, using the fewest measurements. It would be a finite series using the square and cube as its syntax." Others used even

"I don't want to be an art personality," Sol LeWitt said. "I don't even like my picture to be used." This sculpture in Chicago, *Lines in Four Directions*, is a more fitting representation. *Photographs in the Carol M. Highsmith Archive, Library of Congress, Prints and Photographs Division. From the New York Public Library.*

more precise mathematical instructions, though he was horrified if anyone called him a "rationalist."

Some compared LeWitt's work to a new language, which other artists and designers can then speak. Of course, he had not invented drawing on walls. "I think the cave men came first," he said deprecatingly. And conceptual artists had been around since at least the early twentieth century, though few had created lasting systems or methods, focusing instead on individual pieces or ideas. LeWitt had instead found a practical and beautiful way to demonstrate a concept's power and truth. The early sculptures he made were difficult to construct and required special tools. But the wall drawings merely required patience and craft. Anyone could reproduce them. As the individual artist disappeared into the mass of a billion "anyones," LeWitt found a way to transcend it.

He certainly had many critics in the 1960s and 1970s, who accused him of things like "totalitarian or autocratic intonation," "recidivism" and "moral default." And though he often had a close circle of artistic friends, he made personal enemies, too. Sol was "not a friendly human being," said friend and fellow conceptual artist Lawrence Weiner. "Not a saint." He refused to "network," to attend openings, to kiss up to the right people. This could be problematic, particularly since he was one of the many artists of the postwar period who used teams of assistants and hired professional artisans. To them he could be unpleasant but also generous, giving away his work to them, aiding them with their careers. He also helped found the organization Printed Matter, which distributes artists' publications worldwide.

He worked his way through the galleries of New York, often using them as a "total drawing environment," in which there was no framing, with the painted walls themselves becoming the art, full of colored blocks and lines in patterns. Unlike the work of abstract or figurative artists working in the late twentieth century, his repetitive, rigorous designs were almost impersonal, with small modular graphics blown up to gigantic size. Some looked like ripples on a pond. Some seemed like mountain ridges. Some appeared simple, but with study, their true complexity emerged. Some seemed complex but, with careful study, appeared simple. "I would like to produce something I would not be ashamed to show Giotto," he said once. It was an interesting statement, considering how Giotto pioneered the use of individual human faces into medieval paintings, whereas LeWitt never used faces at all. "Aesthetics and ethics are really the same thing," he said when asked to explain why he didn't draw portraits.

By the late 1970s, places like the Museum of Modern Art in New York had embraced conceptual art and Sol LeWitt. The Dutch minimalists did more than embrace him; they rated him one of the best contemporary artists in the world. Around the globe, huge walls and rooms were transformed into mathematically precise murals, sometimes in bright, eye-straining colors, sometimes in pastels, sometimes in black-and-white. The works are not easy to reproduce, taking prevision and time by many artists and curators, all of whom are "carrying out an assignment." Depending on which wall these drawings were created on, they would differ slightly or greatly from each other, which was "a necessary part of the wall drawings," according to LeWitt. "The artist must allow various interpretations of his plan," he wrote. Any errors "are part of the work."

Like all great artists, he moved constantly forward. In Italy in the early 1980s, he began to use eye-straining, primary-color acrylic paints, continuing to experiment with what he called "the logic of the serial image," creating works of symbolic, Pythagorean beauty. Later in the decade, he moved back to his home state, to the village of Chester, where he built a beautiful and practical studio of wood and glass. He may have found inspiration in the geometries of cities like New Britain and New York, but like Alexander

Columbus Boulevard in Sol LeWitt's hometown of New Britain comes alive with his public mural, *Wall Drawing #1105*: "Colored bands of arcs from four corners." *Photograph by Jack Keane.*

Calder and countless other artists, he found the space and peace to create in the quiet Connecticut countryside.

For over two decades longer, he continued to do what he really loved to do: spend day after day drawing and designing in his Chester studio. Though he did not make money "selling" pieces, instead he made it through commissions, with companies and museums asking him for designs. His work became more and more popular, with retrospectives and huge exhibitions held worldwide. And though he maintained his cranky solitude, he also maintained his generosity, collaborating with an architect to design his local synagogue in Chester, including an immediately recognizable, brightly colored geometric design for the ark in which the Torah scrolls are kept.

In the early twenty-first century, he contracted cancer but continued to work every day, creating new black-and-white scribble drawings, often using just a graphite pencil. After he died, other people continued the process, continued to play his scores, producing wall drawings and designs according to his instructions. That would have made him very happy. "The conventions of art are altered by works of art," he said. And his works of art have certainly altered artistic conventions, marrying them with design and mathematics.

But his real accomplishment was to visually separate the conception of a work of art from the act of creating it. "The idea becomes the machine that makes the art," he said. As long as artists remain individuals, that will always be a revolutionary statement.

HENRY C. LEE

CREATIVE CRIMINOLOGIST

Henry Chang-Yu Lee was born in 1938 in Jiangsu province in China but at the end of the Chinese civil war fled with his family to Taiwan. His father didn't make it, drowning when his ship sank in the South China Sea in 1949. A few years later, Lee went to the Central Police College and got a job serving in the Taipei Police Department, doing so well that he was quickly promoted. He became captain at only twenty-five years old, the youngest in the country's history.

Increasingly, he became frustrated at the number of unsolved cases. Being dependent on "interrogation and confession" left him and other investigators feeling like they were guided by the weaknesses of criminals rather than their own abilities. He also hated the "false confessions" that inevitably arose from these methods. Forensic science was "primitive," barely advanced from the methods fictional detective Sherlock Holmes purported to use: fingerprints, ballistics and basic autopsy.

In 1965, he left for the United States with his wife, Margaret Soong Meow Lee, whom he had married three years earlier. He only had fifty dollars in his pocket and did not speak English, but he did not leave behind his work solving crimes. Here in the United States, the use of science to solve cases was heating up. "I was hooked," he said. He earned an undergraduate degree in forensic science at John Jay College of Criminal Justice, then a PhD in biochemistry at the New York University Medical Center, studying under Nobel Prize winner Severo Ochoa. He worked full time for the university to put himself through the school, as well as working as a waiter and teaching kung-fu.

In 1975, he found work as a teacher at the University of New Haven and three years later as the state's chief criminalist and director of the State Police Forensic Laboratory. He was often disparaged for his "foreign accent" but ignored these criticisms, writing article after article about "the application of the natural sciences to matters of the law." He tried to encourage the study of the forensic sciences for police officers and the parallel study of criminal investigation techniques for scientists in the field.

Lee's team pioneered a number of important investigatory methods. They figured out how to extract DNA from evidentiary samples, develop footprints for analysis and enhance bloody fingerprints. In a Boston murder investigation, he was able to find DNA on a toothpick at the crime scene and match it to a suspect. Things like typing isoenzymes in human bone became part of modern forensics thanks to him. In each case, he and his team gathered around a large table, with each member of the team working on individual pieces of evidence. These pieces were then assembled, like a puzzle, into the chain of evidence.

At the time of Helle Crafts's murder in Newtown in 1986, Lee was chief of the Connecticut State Police Forensic Laboratory, located in Meriden during those years. He traveled to Newtown over the Christmas holiday, telling his friends and family that he would not be joining them for dinner that year. He and his team searched the house while Helle's husband, Richard Crafts, was in Florida, and Lee used the luminescent chemical luminol in the bedroom. From the blood spatter pattern, he figured out that she had been murdered in that room. After his team examined hair and bone fragments found at Lake Zoar, they ascertained the pieces were from Helle Crafts. They also proved they had been put through a wood chipper, which records showed Richard Crafts had rented. A tooth matched her dental records. Lee spent three days on the stand reconstructing the murder, and after a mistrial and retrial, Richard Crafts was sentenced to ninety-nine years in prison.

It was the first murder conviction without a corpse in Connecticut history. But it would not be the last; the techniques used by Lee and the prosecutors would become models for future cases and future convictions, not only in the state but across America and the world. Lee himself worked on many of the famous cases featured on the evening news: JonBenét Ramsey, Michael Skakel, Michael Peterson, O.J. Simpson. He examined the evidence from the Washington, D.C. sniper shootings and the 9/11 attack. His courtroom testimony was always riveting; he occasionally stabbed a ketchup bottle with a knife or dropped ink from various heights to demonstrate blood spatter.

Dr. Henry C. Lee's success with forensic science has made him a worldwide celebrity but, more importantly, has popularized its use in criminal investigations. *Courtesy of the Henry C. Lee Institute of Forensic Science.*

But along with the media-covered cases, he was also helping to track down serial killers and defend victims of false accusations. He commuted from his home in Branford over the Quinnipiac River Bridge to West Haven or carried his enormous briefcase to jobs around the globe. He often traveled to China and Taiwan to train police officers and to investigate shootings of politicians and murders that stumped local authorities. His soft, authoritative voice remained utterly convincing as he carefully laid out case after case for juries and judges.

As his methods proved themselves time and time again, the State Police Forensic Lab moved to a huge new state-of-the-art facility, and he continued to serve as director for twenty-two years. He served on the editorial board of *Journal of Forensic Sciences* and in 1998 was appointed Connecticut's commissioner of public safety. He became chief emeritus for the Connecticut State Police in 2000 and served for ten years. "My mother said I should break this glass ceiling," said Lee with a laugh. "There was no height limit, so I hired shorter troopers. Now I look tall."

He tried to retire four or five times, but the governors of Connecticut continued to call him back to service. Of course, they didn't have to prod

The University of New Haven opened the Henry C. Lee Institute of Forensic Science in 2010. The state-of-the-art facility honors its namesake's commitment to advanced forensic research and law enforcement training. *Courtesy of the Henry C. Lee Institute of Forensic Science.*

him too much, since he was never one to "waste time." He could not stop working and tried to fill each hour of the day with some worthwhile task.

His "foreign accent" didn't stop him from lecturing and teaching classes across the United States, writing articles for scholarly journals and advising law enforcement throughout the world. He even hosted the show *Trace Evidence: The Case Files of Dr. Henry Lee* on television and wrote or co-wrote more than thirty books on criminal sciences. He also continued consulting on cases, racking up over eight thousand in forty-six countries, including the examination of mass graves and human rights violations.

In 2007, the University of New Haven opened the Henry C. Lee College of Criminal Justice and Forensic Sciences, honoring the founder of its renowned program. "We've come a long way," said Lee. The center embodied one piece of his lifelong goal of a closer-knit law enforcement community. His own family stayed close, too. His wife, Margaret Soong Meow, taught in New York City and later worked for twenty years at the VA Hospital in West Haven, just down the street from her husband's teaching job. Their two children, Sherry and Stanley, remained close to their parents and settled in their adopted state of Connecticut.

By the second decade of the twenty-first century, Lee said, "The public recognizes forensics as a field; they understand better what it is. They used to think we were in forestry or involved in foreign affairs....People are more interested in forensics and more good students are getting inspired to major in forensics. That might get the justice department to put more resources into forensics, which will bring more justice to our society." Of course, this also meant that the public expected more from forensic scientists, and while television shows demonstrated possibilities, the resources for its use remained far below what was required. Nevertheless, Lee's work increased both awareness and innovation.

"Every branch of science has some influence in forensic science," he said, speaking of the "tremendous advances" in his lifetime. And his work synthesizing these sciences with law enforcement has changed the way we investigate and prosecute crimes. Perhaps, if we're lucky, it will lead to more guilty people being convicted, more innocent people being acquitted and true justice being served.

Chapter 24

BUN LAI

GAME-CHANGING CHEF

In Japan in the early 1970s, Yoshiko Lai was very poor, waiting for her Chinese husband, Yin-Lok, to finish his doctorate. She lived near the shore with her son Bun, and each day they walked together to buy one oyster and one piece of fish. Back in their small room, Yoshiko would steam them, chop them up and add them to rice and vegetables for dinner. Decades later and a continent away, Bun Lai could still taste this simple dish.

With a PhD and MD in hand, Yin-Lok Lai brought the family to New Haven, and little Bun hung out with his father late nights in the lab at Yale. "It probably influenced my focus on science-based decisions," he said. "And my experiments." Yin-Lok also took Bun and his brother Ted out to state parks, working in the car while they flipped over rocks, giving Bun "a love for all things wild." After Yin-Lok and Yoshiko separated in 1982, she knew that she would need to provide for her children. Rather than continue as a clothing designer, she decided to open the first traditional sushi restaurant in New Haven. It was a risk at a time when Chinese was the only Asian cuisine that most Americans felt comfortable eating.

Yoshiko taught her sons the meaning of hard work, cooking both lunch and dinner six days a week at the restaurant. She named the restaurant Miya's after the Japanese word for "shrine" or "temple" and always focused on the sacred aspect of feeding others. The family lived in an apartment building on Prospect Street, growing vegetables in a small garden for what would today be called "farm to table." She, Bun and Ted also foraged all around the county for food to add to Miya's menu. The young boys liked

to dig up burdock roots for their mother, since it was a difficult job that required patience. Bun also liked to fish and made his first money selling his catch to other immigrant families living in their building. The whole place smelled like the kitchens of those families, newly arrived from Africa or Israel—smells "forever imprinted in [Bun's] memory."

The restaurant did well enough that the young Bun Lai could attend nearby Hamden Hall and Yoshiko could bring up her third child, daughter Mie-sara. By the early 1990s, Lai and his friend Dan Schuman worked at Miya's as waiters, putting up posters around town, helping out Yoshiko and the head chef. The chef had been friendly to Lai throughout his decade of work, and Lai had admired him for years. But now the chef seemed aloof, unhappy, silent. He would not teach anyone else how to make sushi properly and insulted Lai often. Lai and Schuman stayed after work, drinking beer and trying to learn how to make sushi from a book. One day during a rush, the chef went too far and insulted one of the waitresses in front of the customers. Lai confronted him, saying, "I've only tried to be helpful. I've never acted like the owner's son, but I'm going to act that way just this once." He fired the chef on the spot and had to go home to tell his mother. She supported him, and they shut down the restaurant briefly.

Bun had always wanted to be a chef, but he was not ready, even after learning the craft from Chef Muto at the nearby restaurant Hama. Living in the basement of Miya's, he and Dan took over in the kitchen and promptly lost half its customer base. Even some people they thought were good friends stopped coming. But he credited this as being the best experience he could have had: "To care so much about what you are doing, and be so bad at it." He also found his most loyal customers in those years and was astounded by "the generosity of human beings."

In 1995, he took his first radical step as a chef and took sugar out of the white rice, an additive used in almost every restaurant. Shortly afterward, he took the unnaturally sugary *kanpyo* roll off the menu and created the sweet potato roll, which spread across the country to almost every sushi menu. It was the first of a large "plant-based" menu, and by the year 2000, many thought of Miya's as a "vegetarian" sushi restaurant, even though they still included fish on the menu. This was his first application of ecologically sound ideas and the beginning of creating the first sustainable sushi restaurant in the world.

Since the early twentieth century, New Haven has featured an unusually high number of great restaurants for such a small city, including the country's oldest hamburger joint and best-rated pizza places. But working

On their own, the ingredients found at Miya's might not be game-changing, but like all great chefs, Bun Lai combines them in an innovative and delicious way. *Courtesy of the author.*

in a small city you have to charge less, and Miya's ingredients tended to be more expensive. Even gardening and foraging added another layer of work and expenses. Lai's commitment to paying good wages and including cheaper items on a "late night" menu often hurt the bottom line, too. "We don't need to do that," he said. "Serving a bowl of ramen or a sushi roll for the price of a Happy Meal."

The next step was taking fish that were caught or farmed in an ecologically damaging way off the menu, working toward practices that could be maintained long term. This required removing nine out of the ten species that ordinary sushi restaurants used. Other seafood chefs had attempted this before, but Miya's became the first sushi restaurant to successfully do so. And then, what began as part of this practice—the use of invasive species— became a full menu project. Lai partnered with the Thimble Island Oyster Company in Branford, renting out seventy-five acres of ocean and diving for seafood and plants. He also began collecting the invasive and destructive Asian shore crabs for the menu at Miya's, saving the company's oysters from their claws. By 2005, Lai had created the world's first invasive species menu,

including vegetables like Japanese knotweed and meat like lionfish. After all, as he said at the time, "if you can't beat them, eat them."

Of course, this required making "food that people are not used to eating." Some people reacted with actual horror to the dishes on the menu. "Every single day," Lai said, "we have people who walk out on us." How could he combat these prejudices? The answer was in every way possible. Dishes must not be experimental for the sake of experimentation; they must taste good together in unexpected and true ways. The sushi had to have fun names, he decided, like the cornmeal and clam–based "Sweet Nature Kabuki Girl," the goat cheese and Berber spice "Tyger Tyger" and Applewood-smoked Connecticut trout and mushroom "Kilgore Trout." There should be textural contrasts as well as flavor contrasts and complements, like pairing soft potato wrap and Camembert lemon dill sauce with crunchy *kanibaba* crabs. As much as possible should be homemade: ginger infused with honey and vinegar, seaweed grown in a nutrient-rich tank, garlic and scallions pickled on-site. The décor should remain unpretentious and simple, and the menu should be part storybook, part encyclopedia, part literature. Guests could be educated while they enjoyed.

He also wrote articles for magazines like *Scientific American* and spoke at organizations like the National Geographic Society. The important thing was to spread the idea, not get credit for it, something that every chef and craftsperson has to deal with. You can't patent a dish, something that became painfully obvious as more "famous" chefs from all over the country imitated Miya's. "I try to keep my ego out of it," he said. "I don't want to bog down my mind. I want to do work that's meaningful."

Although his innovations were game-changing, he did not see them as counter to tradition. "I consider my recipes much more traditional than many of the recipes that are traditional in Japan right now," he said. The reason was that most of the fish on Japanese menus was farmed elsewhere, using questionable practices and chemicals. The Japanese of the nineteenth century ate local fish and plants, which is exactly what guests at Miya's were doing. His movement toward the use of brown rice and whole grains instead of white rice, rather than being some radical development, was in reality a move back to the roots of traditional foods.

By the second decade of the twenty-first century, he could finally afford to move into his own place and bought a ten-acre farm in Woodbridge, where he planned to take the evolution of Miya's on its next wild ride. "Cuisine is not something that is static," he said. "It keeps evolving as tastes evolve." At first, he harvested dandelion from the fields and mushrooms from the forest

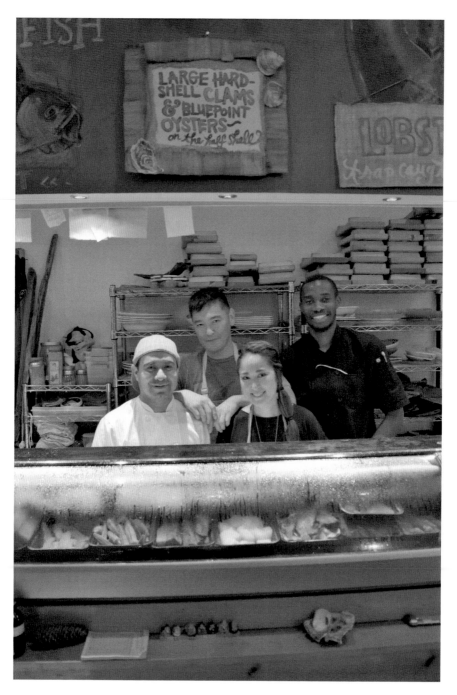

Chef Bun Lai, Mie-sara Lai, Luis Tlalmis Leon and Alain Malimba get ready for the dinner rush at Miya's. *Courtesy of the author.*

but soon began to more methodically cultivate what most people would call "weeds," like sorrel and lamb's quarters, since they were "higher in nutrients, naturally resistant to pesticides." It was a long way from the little garden his mother, Yoshiko, kept at the Yale Apartments thirty years earlier.

His mother continued to help out in the kitchen, and the rest of the family returned to Miya's, with his younger sister Mie-sara working in the front of the restaurant, organizing special events and learning to make the sushi herself. His brother Ted had been a top banker in New York but came back to help out at Miya's. "There isn't a better way of helping people than through this place," he said. The curiosity that drove Lai to create also led him to friends who helped him do practical things, like infuse sakes and distill liquors, and consider more philosophical ideas in his "constant search to understand what it is to be human." As he put it, "Nobody who ever creates anything of any importance ever does it without the help and inspiration of others."

On rare days off, he said, "I like to drive on the Connecticut back roads and find myself in a strange place." It is the same endless curiosity that led him beyond the questions of one restaurant's daily menu. While exploring the sea and shore of his adopted home, he found the ingredients of the future.

SELECTED BIBLIOGRAPHY

Anderson, Sarah. "Chef Bun Lai's Sustainable World." *The Cook's Cook*, May 2017. thecookscook.com/featured-chefs/chef-bun-lais-sustainable-world.

Barnum, P.T. *Life of P.T. Barnum*. New York: Redfield, 1855.

Black, Stephen. *Eugene O'Neill: Beyond Mourning and Tragedy*. New Haven, CT: Yale University Press, 1999.

Bloom, Lynn Z. *Doctor Spock: Biography of a Conservative Radical*. New York: Bobbs-Merrill Company, Inc., 1972.

Brown, William. *The Life of Oliver Ellsworth*. New York: Macmillan and Co., 1905.

Calder, Alexander. *Calder: An Autobiography with Pictures*. New York: Pantheon Books, 1966.

Carse, James. *Jonathan Edwards and the Visibility of God*. New York: Charles Scribner's Sons, 1967.

Chernow, Ron. *The House of Morgan: An American Banking Dynasty and the Rise of Modern Finance*. New York: Grove Press, 2010.

Dockett-Mcleod, Wilma. *Ebenezer Don Carlos Bassett: A Biographical Sketch of America's First American of African Descent Diplomat*. N.p.: AuthorHouse Press, 2005.

Dowling, Robert. *Eugene O'Neill: A Life in Four Acts*. New Haven, CT: Yale University Press, 2014.

Elwood, Douglas. *The Philosophical Theology of Jonathan Edwards*. New York: Columbia University Press, 1960.

Fuller, Edmund. *Prudence Crandall: An Incident of Racism in Nineteenth Century Connecticut*. Middletown, CT: Wesleyan University Press, 1971.

Garrels, Gary, ed. *Sol LeWitt: A Retrospective*. New Haven, CT: Yale University Press, 2000.

Gelb, Arthur, and Barbara Gelb. *O'Neill: Life with Montecristo*. New York: Applause Books, 2000.

Green, Constance. *Eli Whitney and the Birth of American Technology*. Boston: Little, Brown, and Company, 1956.

Hall, Donald, ed. *The Oxford Book of American Literary Anecdotes*. New York: Oxford University Press, 1981.

Harris, Neil. *Humbug: The Art of P.T. Barnum*. Boston: Little, Brown, and Company, 1973.

Hedrick, Joan D. *Harriet Beecher Stowe: A Life*. New York: Oxford University Press, 1994.

Hepburn, Katharine. *Me*. New York: Alfred Knopf, 1991.

Keiler, Allan. *Marian Anderson: A Singer's Journey*. New York: Scribner, 2000.

Keller, Helen. *The Story of My Life*. New York: Bantam Dell, 1990.

Kendall, Joshua. *The Forgotten Founding Father: Noah Webster's Obsession and the Creation of an American Culture*. New York: G.P. Putnam's Sons, 2010.

Knight, Christopher. "Sol LeWitt, 78; Sculptor and Muralist Changed Art." *Los Angeles Times*, April 10, 2007. articles.latimes.com/2007/apr/10/local/me-lewitt10.

Lai, Bun. "Invasive Species Menu of a World-Class Chef." *Scientific American*, September 1, 2013. www.scientificamerican.com/article/a-top-chef-s-recipes-for-eating-invasive-species.

———. Personal interview. Woodbridge, CT, August 7, 2017.

———. "Why Fight Them When We Can Eat Them?" *Harvard Design Magazine*, no. 39. www.harvarddesignmagazine.org/issues/39/why-fight-them-when-we-can-eat-them.

Lampos, Jim, and Michaelle Pearson. *Remarkable Women of Old Lyme*. Charleston, SC: The History Press, 2015.

Lee, Henry C., and Jerry Labriola. *Dr. Henry Lee's Forensic Files*. Amherst, NY: Prometheus Books, 2006.

Lee, Henry C., and Thomas O'Neil. *Cracking Cases: The Science of Solving Crimes*. Amherst, NY: Prometheus Books, 2002.

Legg, Alicia, ed. *Sol Lewitt: The Museum of Modern Art New York*. New York: Museum of Modern Art, 1978.

Mann, William. *Kate: The Woman Who Was Hepburn*. New York: Henry Holt, 2006.

Marsden, George M. *Jonathan Edwards: A Life*. New Haven, CT: Yale University Press, 2003.

Miller, Perry. *Jonathan Edwards*. New York: William Sloane Associates, 1949.

Mirsky, Jeanette, and Allan Nevins. *The World of Eli Whitney*. New York: Macmillan Company, 1952.

Moers, Ellen. *Harriet Beecher Stowe and American Literature*. Hartford, CT: Stowe-Day Foundation, 1978.

Morgan, Mary, and Benjamin Spock. *Spock on Spock*. New York: Pantheon Books, 1985.

Mycek, Mary J., Marian K. O'Keefe and Carolyn B. Ivanoff. *Ebenezer D. Bassett (1833–1908)*. Derby, CT: Valley Historical Research Committee, 2008.

Nielsen, Kim. *The Radical Lives of Helen Keller*. New York: New York University Press, 2004.

Nyberg, Ann. *Remembering Katharine Hepburn*. Guilford, CT: Globe Pequot, 2017.

Olmsted, Denision. *Memoir of Eli Whitney*. New York: Arno Press, 1972.

Olmsted, Frederick Law. *The Papers of Frederick Law Olmsted*. Edited by Charles McLaughlin. Baltimore, MD: Johns Hopkins University Press, 1977.

O'Neill, Eugene. *Long Day's Journey into Night*. New Haven, CT: Yale University Press, 2002.

———. *Nine Plays*. New York: Modern Library, 1954.

Purmont, Jon E. *Ella Grasso: Connecticut's Pioneering Governor*. Middletown, CT: Wesleyan University Press, 2012.

Pyrek, Kelly. *Forensic Science Under Siege: The Challenges of Forensic Laboratories and the Medico-Legal Investigation System*. N.p.: Elsevier Science, 2007. ProQuest Ebook Central.

Roper, Laura Wood. *FLO: A Biography of Frederick Law Olmsted*. Baltimore, MD: Johns Hopkins University Press, 1973.

Rower, A.S.C. *Calder Sculpture*. New York: National Gallery of Art, 1998.

Saxon, A.H. *P.T. Barnum: The Legend and the Man*. New York: Columbia University Press, 1989.

———, ed. *Selected Letters of P.T. Barnum*. New York: Columbia University Press, 1983.

Schiff, David. "The Many Faces of Ives." *Atlantic Monthly* 279, no. 1 (1997): 84–87. www.theatlantic.com/magazine/archive/1997/01/the-many-faces-of-ives/376756.

Sheaffer, Louis. *O'Neill: Son and Artist*. New York: Paragon House, 1990.

Silverman, Barbara. *Alice Hamilton: A Life in Letters*. Cambridge, MA: Harvard University Press, 1984.

Sol LeWitt. Directed by Chris Terrink. Icarus Films, 2012. DVD.

Spock, Benjamin. *The Commonsense Book of Baby and Child Care*. New York: Duell, Sloan & Pearce, 1946.

Stowe, Charles Edward. *The Life of Harriet Beecher Stowe*. 1889. Project Gutenberg, 2004. www.gutenberg.org/files/6702/6702-h/6702-h.htm.

Stowe, Lyman Beecher. *Saints and Sinners and Beechers*. Indianapolis, IN: Bobbs-Merrill Co., 1934.

Strane, Susan. *A Whole-Souled Woman: Prudence Crandall and the Education of Black Women*. New York: W.W. Norton and Company, 1990.

Strouse, Jean. *Morgan: American Financier*. New York: Random House, 1999.

Stuart, Isaac Williams. *Life of Jonathan Trumbull, Senior, Governor of Connecticut*. Boston, 1859.

Swafford, Jan. *Charles Ives: A Life with Music*. New York: W.W. Norton and Company, 1996.

———. "This American Composer: Why You Should Listen to Charles Ives." *Slate*, June 1, 2009. www.slate.com/articles/arts/music_box/2009/06/this_american_composer.html.

Sweeney, James Johnson. *Alexander Calder*. New York: Museum of Modern Art, 1951.

Teal, Christopher. *Hero of Hispaniola: America's First Black Diplomat, Ebenezer D. Bassett*. Westport, CT: Praeger, 2008.

Toth, Michael. *Founding Federalist: The Life of Oliver Ellsworth*. Wilmington, DE: ISI Books, 2011.

Twain, Mark. *The Autobiography of Mark Twain*. Vol. 2. Edited by Benjamin Griffin and Harriet E. Smith. Berkeley: University of California Press, 2013.

Warfel, Harry, ed. *Letters of Noah Webster*. New York: Library Publishers, 1953.

Watanabe, Myrna. "Forensic Scientist Henry Chang-Yu Lee." *The Scientist*, April 3, 2000. www.the-scientist.com/?articles.view/articleNo/12766/title/Forensic-Scientist-Henry-Chang-Yu-Lee.

Weaver, Glenn. *Jonathan Trumbull: Connecticut's Merchant Magistrate*. Hartford: Connecticut Historical Society, 1956.

Zafran, Eric, Alexander Calder, Elizabeth Mankin Kornhauser, Cynthia E. Roman and Wadsworth Atheneum Museum of Art. *Calder in Connecticut*. Hartford, CT: New York: Rizzoli International Publications, 2000.

ABOUT THE AUTHOR

Eric D. Lehman teaches literature and creative writing at the University of Bridgeport, and his essays, reviews and stories have been published in dozens of journals and magazines, from *The Wayfarer* to *Gastronomica*. He is the author of thirteen books, including *A History of Connecticut Food*, *Literary Connecticut* and *Homegrown Terror: Benedict Arnold and the Burning of New London*. His novel *Shadows of Paris* won the Novella of the Year from the Next Gen Indie Book Awards, earned a Silver Medal for Romance from the Foreword Review Indie Book Awards and was a finalist for the Connecticut Book Award. He lives in Hamden with his wife, poet Amy Nawrocki, and their two cats.